HAROLD'S CROSS

JOE CURTIS

The
History
Press
Ireland

First published 2011

The History Press Ireland
119 Lower Baggot Street
Dublin 2
Ireland
www.thehistorypress.ie

© Joe Curtis, 2011

The right of Joe Curtis to be identified as the Author
of this work has been asserted in accordance with the
Copyrights, Designs and Patents Act 1988.

British Library Cataloguing in Publication Data.
A catalogue record for this book is available from the British Library.

ISBN 978 1 84588 702 5

Typesetting and origination by The History Press
Printed in Great Britain

CONTENTS

ACKNOWLEDGEMENTS

Many thanks to the archivists in Our Lady's Hospice (Sister Marie O'Leary), St Clare's Convent (Sister Marie Feely), Mount Argus (Fr Brian Mulcahy), and the Principal in Harold's Cross National School (Bernadette Kehoe).

Photo credits are shown after each caption. Peter Barrow Photography took all the modern aerial photos, many specifically for the owners of different buildings and sites. Captain Morgan took some lovely aerial photos in the 1950s, and these are now owned by The National Library. A few sources cannot be traced. All other photos by the author.

Many individuals helped or provided old photos, including Mary Corrigan, John Gaffney, Jack Nolan, Sean Mc Manamon, Patricia Pierce, Madge Fitzpatrick, Anthony Carberry, Jim and Joan Smith, and Seamus Whelan.

My publisher, Ronan Colgan, deserves a special mention, for undertaking this project in the present recession.

INTRODUCTION

Although Harold's Cross is now a suburb on the south side of Dublin, it was once akin to the best little town in Ireland, being completely self-sufficient, with schools, churches, shops, pubs, hospital, orphanage, convents, monastery, cinema, a major cemetery, mills and factories, park, canal, large and small houses, dog track, barracks, and many farms and orchards.

The Earl of Meath (Brabazons) owned most of the land for many centuries, having been granted the Abbey of Thomas Court and Donore by the King in 1544. The Protestant Archbishop also had some land, but it stopped at an old wall on the south side of the present St Clare's National School. The Archbishop's land included the Green, which was commonage, until it was enclosed with railings in 1894.

The High Cross at the north end of the Park was only erected by the Old IRA in 1954, and has nothing to do with the name of the area. The Harolds were a farming family in Rathfarnham (Harolds Grange was their estate), and their boundary was reputedly marked by a cross just south of Kenilworth traffic lights, although there is no evidence of this.

The Hospice for the Dying dates back to 1845, when Mother Mary Aikenhead, the foundress of the Sisters of Charity, bought a house called Greenmount, for a new convent. The nuns operated a good-sized farm, with cows, pigs, hens. The chapel was never open to the public. Marymount Schools were an integral part of the hospice for over a hundred years, and likewise the Children of Mary sodality.

The Poor Clares came to Harold's Cross in 1804 to start a girls' orphanage, and later a National School. They too had a working farm. Their lovely little chapel was always open to the public, but is now closed.

The Passionists started Mount Argus monastery in 1856, and supported themselves by farming and preaching.

John Keogh, a friend of Wolf Tone, sold his large estate, Mount Jerome, in 1836, to a cemetery company, largely for Protestant burials. The Anglican church (now Russian Orthodox) was built beside the entrance to Mount Jerome in 1838 as a preaching church.

An old cottage beside the right-hand side of the entrance to Mount Jerome was converted into a Penal chapel in 1798, and then into Harold's Cross National School in 1833. In 1937, the school moved to Clareville Road. The Holy Rosary Church was not built until 1938.

The River Poddle supplied drinking water to Dublin city from the thirteenth century, when a branch was taken off in Mount Argus ('the Tongue'). This river powered many mills in the area, via large water wheels, including Loader Park Paper mill beside Mount Argus, Harold's Cross Flour Mill (later Laundry) opposite Mount Jerome, and especially the Greenmount and Boyne Linen Co. These mills operated for hundreds of years, and provided much employment, especially for girls.

Entertainment was provided by concerts in Marymount Hall in the hospice, Century Hall (Anglican) just past the Rosary church, Rosary Hall, Loader Park Mill (after being bought by Mount Argus in 1943), and in the Kenilworth Cinema (later called the Classic). The numerous pubs attracted patrons from far and wide, especially on racing nights in the Greyhound Stadium. Clusters of shops in three different parts of Harold's

Cross catered for the daily needs of every housewife. The Grand Canal was a good spot for fishing, with an occasional barge passing through. Two army barracks, Cathal Brugha and Griffith, both dating from the early years of the nineteenth century, overlooked this canal.

The Greenmount Oil Co. was situated along the main road, with the Greenmount Linen Co. behind. The Oil Co. operated from about 1896 to the 1960s, and was the previous site of Irish Whiskey Distillery (1873-93), and before that, Alexander Perry & Co., brewers of mild and pale ale.

Clarnico Murray manufactured lovely sweets from their factory in Mount Tallant Avenue (St Pancras Works) from 1926 to 1973. In the 1960s, Tayto made their delicious potato crisps in a factory at Tivoli Avenue, opposite the Rosary church.

The district was in the Rathmines Township from 1847 to 1930, which contributed greatly to the orderly development of housing, water supply, street lighting, etc.

Harold's Cross was mainly a Protestant area, but with a strong Quaker presence (Pims and Perrys in Greenmount), and a few Jewish establishments.

Nowadays, most of the historic buildings are still in use, but the big employers are gone, and likewise farming activities. The hospice is still in use, but Marymount Schools are gone. St Clare's Orphanage is long closed, and the nuns have recently built a new convent, in preparation for the sale of the original buildings for development purposes. Mount Argus monastery has been sold for development, allowing the few remaining priests to move into a new monastery. The Anglicans are gone, having sold their church to the Russian Orthodox Church, and their 1882 Parochial Hall to a firm of accountants. The cinema has been demolished, thus ending the era of the Rocky Horror Show. Some pubs were demolished to make way for apartments, such as the Irish House, and Grove Inn. Paddy Walsh Cycles was demolished to make way for an obtrusive block of apartments. The abattoir just over Emmet Bridge was also developed for a block of apartments. Part of the Dog Track was sold for housing. All in all, Harold's Cross hasn't fared too badly, and is still a fascinating and historic place to live.

1

THE PARK

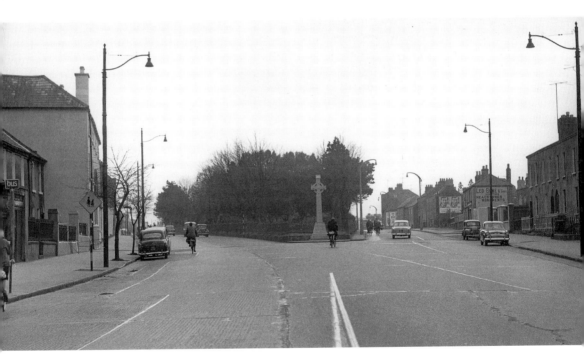

Harold's Cross was relatively traffic-free in the 1960s, so there was no need for traffic lights. However, there were frequent traffic accidents in this area, as neither motorist from Kimmage nor Terenure would yield on their way into town. Note the simple bus stop on the left, beside the lady cyclist. St Clare's Orphanage is on left. Fr Charles (now a Saint) of Mount Argus, injured his foot here in 1881, when his horse-drawn taxi cab overturned. (Courtesy of St Clare's Convent)

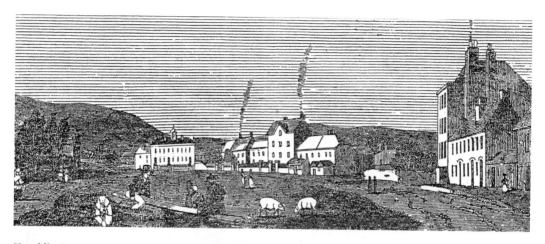

Harold's Cross Green was commonage in 1835, as depicted in the *Dublin Penny Journal*. The tall building on the right was known as the Big Buggy, a militia barracks, and is still standing, minus the top two storeys, used by Hall Electrical. (Courtesy of the Royal Irish Academy)

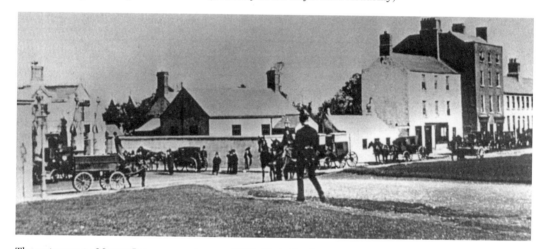

The entrance to Mount Jerome cemetery, *c.* 1880. Note the four-storey Big Buggy on the right, the Constable on the green (no railings yet), and the National School to the immediate right of the cemetery entrance. The village blacksmith was in the cottage to the right of the school up until the 1960s. (Courtesy of the Irish Architectural Archive)

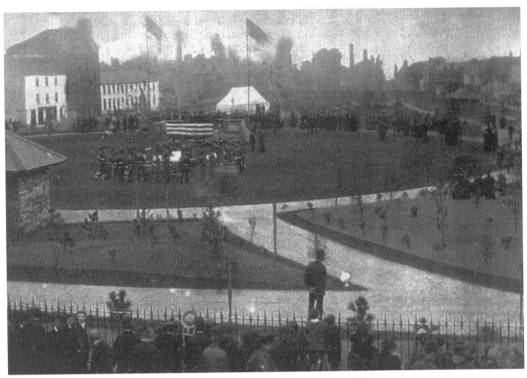

The official opening of Harold's Cross Park in 1894, looking north. Big Buggy is at the top left. (Courtesy of Dublin City Archives)

Harold's Cross Park in 1894, looking east, including the Dripping Pool. One of the low houses in the centre was demolished in 1928 to form an entrance to the new Greyhound Stadium. (Courtesy of Dublin City Archives)

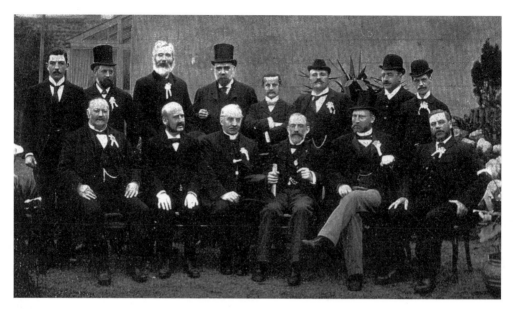

Harold's Cross Improvement Association was responsible for enclosing the Green to form a park in 1894. From left to right, front row: W. Fanagan, E. Ball, Revd D. O'Neill, J. Ellis, Dr J. Keys, R. Cassels. Back row: W.B. Ellis, T. Keogh, J. Dignam, W. Maher, T.N. Smith, P. McDonnell, R. Bordman, G.J Murphy. (Courtesy of Dublin City Archives)

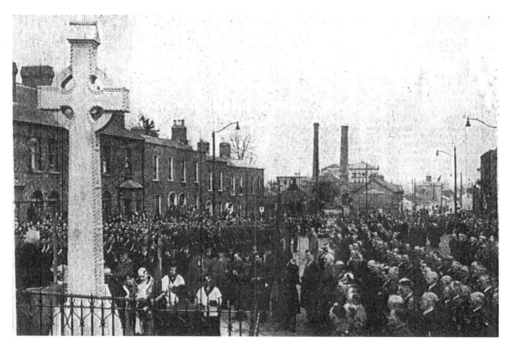

The unveiling of the Old IRA High Cross on 25 April 1954, by President Sean T. O'Ceallaigh, and blessed by the parish priest of the Holy Rosary Church, Fr Kevin Brady. Note the buildings and tall chimney stacks of the Greenmount Oil Co. in the background. (Courtesy of the *Irish Press*)

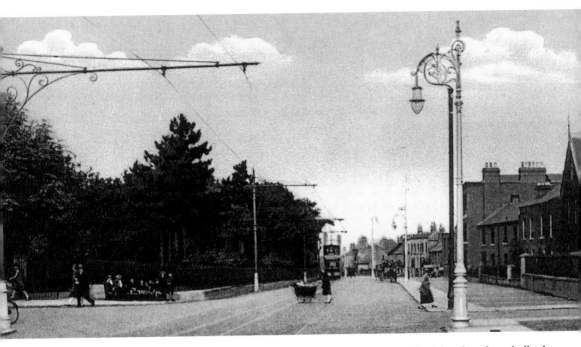

An early twentieth century postcard of Harold's Cross Park, looking north. A low fire-alarm bollard can be seen on extreme left and Greenmount Oil Co. chimneys are in the background, with Oldcourt on right. (Courtesy of Seamus Kearns)

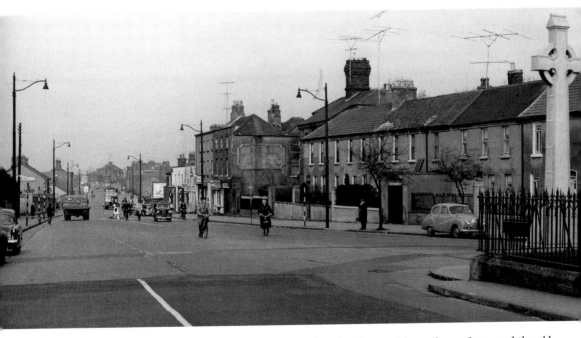

A 1960s photo of the Cross, looking north. Note the television aerials on the rooftops, and the old cars. The pedestrian zebra crossing is located in front of the hospice, and a bus can be seen behind. (Courtesy of St Clare's Convent)

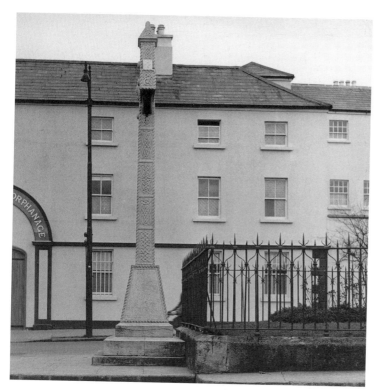

A 1960s view of High Cross, erected by the Old IRA, at Easter 1954. It was carved from one large slab of limestone by Eamon Crowe of Harrisons Stone Masons. Note St Clare's Orphanage in background. (Courtesy of St Clare's Convent)

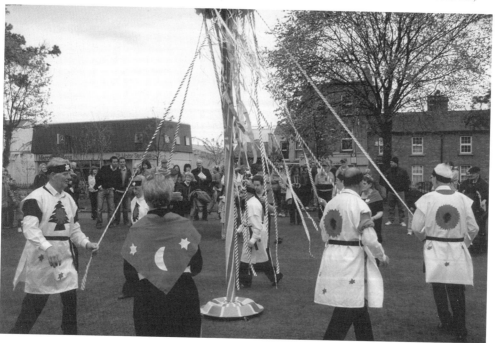

The Maypole Festival was revived in May 2010, accompanied by traditional Irish music. 'Active Age Group' from Drumreilly in Leitrim, did the honours. TR Motors and the Greyhound pub can be seen in background, with entrance to Greyhound Stadium just visible on left.

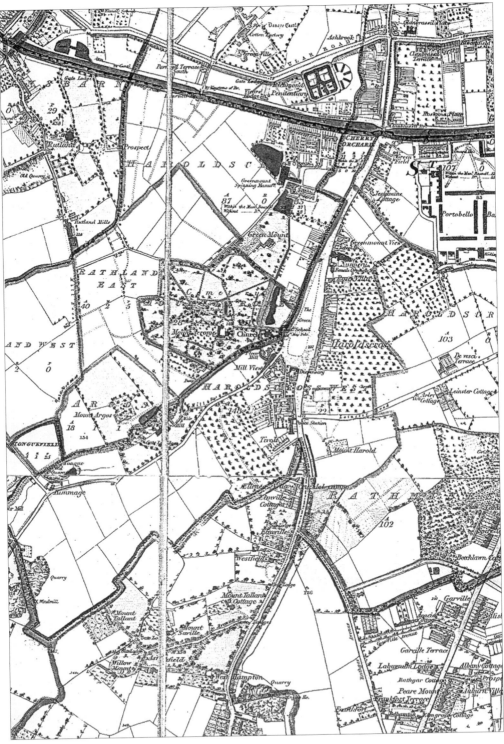

1837 Ordnance Survey map. Note the big mill ponds to the north and south of Greenmount Spinning Manufactory. (Courtesy of Trinity College Map Library)

HAROLD'S-CROSS.

Harold's Cross.

Mr. Montrose Mitcheltree, chymist
Christopher Warren, carpenter and smith
Mr. Patrick Duggan.
John Griffin, esq.
Joseph Butler, esq.
William Gray, huxter
James Campbell, army agent
John Kathrens, esq.
Mr. Walker
Alexander Pindar, floorcloth and baize manufacturer
Mrs. Daly, Green Mount View

Harold's-Cross—continued

Robert Connolly, law wigmaker
Miss O'Reilly, French and English school
James Byron, esq.
Mrs. Cunningham
John Henry Longford, esq.
Female Orphan House and Convent; Mrs. Doyle, mistress
Bernard O'Neill, esq. Elm Villa
Patrick Boyd, esq. Rose Grove
Moses Ingram, huxter
Mary Brophy, dairy
Edward Costello, bricklayer and huxter

Harold's-Cross—continued.

No.
- 14 Catherine Taylor, vintner
- 15 Edward Dunn, dairy
- 16 Thomas Lynch, paper-mould maker
- „ William Goulding, boot and shoemaker
- 17 Lodgings
- 18 Joseph Kearns, esq.
- 19 Fernando Maximo, saddler
- „ Emma Parker, toy seller
- 20 William Mason, esq.
- „ Peter Murphy, dairy
- 21 Joseph Spain, dairy
- 22 Nicholas Maher, grocer & provision dealer
- 23 William Donnellan, esq.
- 24 Mrs. Campion
- 25 Miss O'Reilly
- 26 William Adams, esq.
- 27 Thomas Gilligan, esq.
- 28 Robert Manning, esq.
- 29 George Irwin, esq. attorney
- 30 Lodgings
- 31 Patrick and Thomas Monks, prov. dealers
- 32 John Collier, esq.
- „ Mrs. Hunt, pelisse maker
- 33 Mrs. Ebbs, French and English school
- 34 Joseph Oakes, tailor
- 35 Mark Dunn, general provision stores
- 30 Richard Phelan, esq.
- „ Mary Harman, milliner
- 31 Nicholas Martin, esq. and 14 Cork hill
- 32 Peter Gernon, esq.
- 33 John Lowry, esq.
- 34 Miss Taylor
- 35 Captain William Hannigan
- 36 James Ward, baker
- William Gibton, esq.
- Mr. Mark Lalor
- Michael Byrne, grocer
- Mr. Peter Dowdall
- Rev. Edmund Curtis
- Miss Gason
- Richard Collins, gunsmith
- Samuel Orson, boot and shoemaker
- John Byrne, dairy
- John Savage, esq.
- Mr. Byrne
- Arthur Snow, esq. architect
- James Fitzgerald, esq.

Harold's-Cross—continued.

No.
Mrs. Madden
Francis Dillon, grocer and vintner
Joseph Murphy and Son, flour mills
Michael Keogh, esq. Mount Jerome
Roman Catholic Chapel
Harold's Cross National Free Schools
Mr. Samuel Parke
Mr. John Reid
Martin Kenny, dairy
Mary Waddick, do.
Matthew Hayden, huxter
Mr. George Holdship
Captain Robert O'Regan
Mrs. Anne Cullen
Mrs. Whelan
Mrs. Rogers, Hollymount
Roger Handley, esq.
Standish Peppard, esq. attorney
Mr. Edmund Dwyer
Mr. James Murphy, mercantile academy
Mr. Patrick Rice, and 7, Upper Ormond-quay
Mr. John Stewart
Joseph Robinson, Pim, Green Mount cotton mills, and 11 Eden quay
Timothy M'Carthy, boot and shoemaker

Mountain View Avenue.

John Quinton, esq.
John William Walker, esq.
Mr. John Carey
Mr. Joseph Cluff
Mr. John Wilson, collector of public money
Mr. James Howard
Mr. Michael Fannin

Shamrock Villa.

- 1 Nicholas Purcell, esq. attorney
- 3 William O'Brien, teacher of astronomy
- 4 John M'Clean, teacher
- 5 Richard Gilbert, esq.
- 6 Simon Irwin, esq. surveyor of lands
- 7 Mr. Martin Kelly
- 8 Mr. William Richey
- 9 Mr. George Seville
- 10 Mr. William Hurst
- 11 Mrs. Duigan, Mountain View

1834 PETTIGREW AND OULTONS DIRECTORY

The forerunner of Thoms Street Directory reveals a fascinating collection of locals and businesses in 1834.

2

BUSINESS AND SHOPS

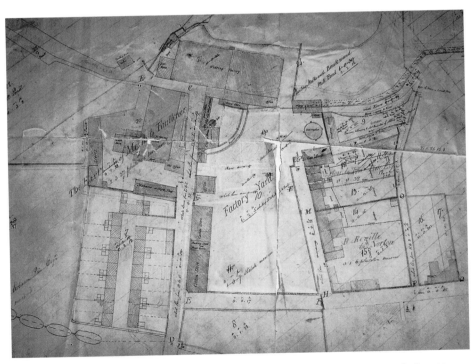

An early nineteenth-century map of Greenmount Spinning Manufactory, before it was extended north. The houses at the bottom left are Greenmount Court. The buildings to the right of the factory yard are houses. The present four-storey mill has not yet been built. The big building in the centre left is the original 1807 mill, and is still in existence, including the basement water turbine, which was fed from the River Poddle, via the mill ponds. (Courtesy of the National Library)

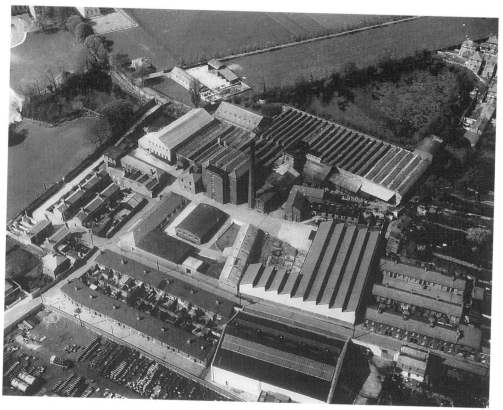

Greenmount & Boyne Co. in the 1950s. Note the two mill ponds at the rear, separated by the hospice farmyard. (Courtesy of the National Library)

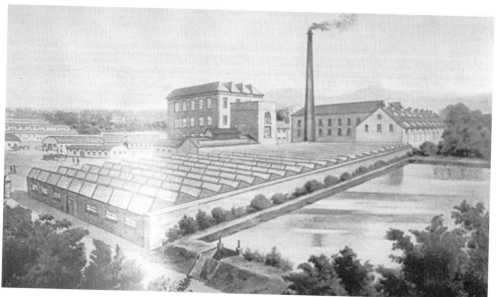

Greenmount & Boyne Co. looking south. The big mill pond can be seen on the right. Most of these buildings are still standing today. (Courtesy of Millmount Museum, Drogheda)

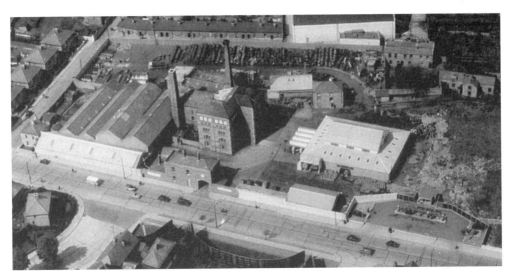

Greenmount Oil Co. in the 1950s. Founded by Louis le Brocquy in 1886 in Ringsend, it moved to Harold's Cross in 1896. Limekiln Lane is at the rear, as is the former Department of Posts and Telegraphs depot (before that it was Booth Poole car servicing). (Courtesy of the National Library)

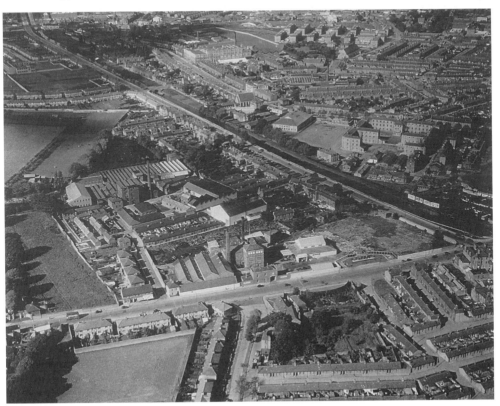

Greenmount Oil Co. fronting Harold's Cross Road with Greenmount & Boyne Linen Co. immediatly behind, 1950s. (Courtesy of the National Library)

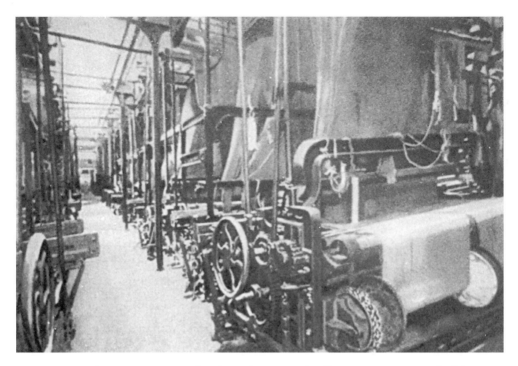

Greenmount & Boyne Co. in a 1920s brochure. (Courtesy of Millmount Museum, Drogheda)

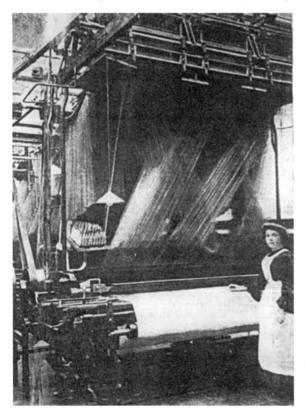

The interior of Greenmount & Boyne Co. from a 1920s brochure. (Courtesy of Millmount Museum, Drogheda)

DOCKRELL LIMITED.

AUCTIONEERS AND VALUERS.

GREENMOUNT SPINNING COMPANY, LTD.,

HAROLD'S CROSS, DUBLIN.——IN LIQUIDATION.

HAVING SOLD THE FACTORY PREMISES, we are now further instructed to

SELL THE MACHINERY & PLANT BY PUBLIC AUCTION,

EACH DAY

On MONDAY, TUESDAY, & WEDNESDAY, 12TH, 13TH, AND 14TH JUNE

(BEING POSTPONED FROM 6th, 7th, and 8th JUNE).

350 h.p. Compound Condensing Steam Engine, 100 h.p. do. Steam Engine, 2 Lancashire Boilers, 27' 6" long, working pressure 150lbs., super heaters; 160 Tube Economiser, 559 Plain Looms, from 31 to 81" Reed space; 121 Damask Looms, 31" to 101" Reed space; 9 Weft Winding Machines, 120 and 90 spindles; 8 Warp Winding Machines, 90, 80, and 72 drums; 2 Hydraulic Mangles, 95" and 84" wide; Humidifying and Ventilating Plant, two 5-Bowl Calenders, 82" and 45"; Hydraulic Baling Press, 2 Cropping Machines, Lapping, Folding, Measuring, and Rolling Machines; Dust Extracting Plant, 6 Double Beam Beetling Engines, 2 Cotton Dressing Machines, 58½" and 63" wide on cylinder; Beaming Machine, various Copper Mixing Tanks, 7 various Linen Warping Machines, 4 Linen Warp Dressing Machines, 3 C.I. Boiling Pots, 5' 9" diameter x 4' 9" depth; 1-Ton Crane; 1 2-Throw Bucket Pump; Card Repeating Machine, Lacing do. Stamping do., Yarn Softening do., Planing, Slotting, and Drilling Machines; 21" Centres Lathe, on 35ft. bed; 5 other Lathes; Circular Saw Bench, about 20 various Vices, Belting, Shafts, Pulleys, Brass Crown Reeds and Dressers and Heddles; Platform Scales and Weighbridges, Winches, Steam Jacketted Copper Boiler, Hydro Extractor, C.I. Dye Boxes, C.I. Tank, 6' diameter, 5' depth; about 450 Weavers' Beams in sizes; 100 Warping Beams, Beam Stands, 2-ton and other Chain Blocks; Trucks, new Cotton Driving Ropes, Belt Dressing, 40,000 Pirns, 9,000 Spools, Palm Oil, heavy Cylinder Oil, Gloy, Carrigheen Moss, 6 4/4 Beams, 1,900 Ends, 40 Line Boiled, 58 Cuts, 90 Yds., 165 Bundles; 50 W.I. Cradle Yarn Racks, well-made Exhibition Stand, in sections, with plate glass sides. Also a vast quantity Miscellaneous Loom Parts, Sides, Forge Equipment, Sley Swords, Jacquards and Parts, 550 Shuttles, Yarn Testing Machine, 12-Ton and other Jacks, Stocks and Dyes, Mechanic's and Carpenter's Tools, Cramps, Steam and Water Piping, Canteen Equipment, Oil Tank, etc., etc.

ON VIEW FRIDAY AND SATURDAY, 9th and 10th JUNE.

ORDER OF SALE:

MONDAY, 12th JUNE—ALL THE LOOMS, AND IF TIME PERMITS SOME LOOM PARTS.
TUESDAY, 13th JUNE—ENGINES, BOILERS, ALL THE MACHINES AND BEAMS.
WEDNESDAY, 14th JUNE—MECHANIC'S SHOP, TOOLS, and MISCELLANEOUS ITEMS.

CATALOGUES, 1/- each.

1922 newspaper advertisement for sale of machinery after the company went into liquidation. The Boyne Weaving Co. in Drogheda bought the company, to create the Greenmount & Boyne Linen Co.

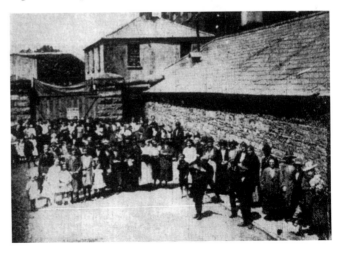

Striking workers in 1922 at Greenmount Spinning Co. They are mostly women and girls. (Courtesy of the *Freemans Journal*)

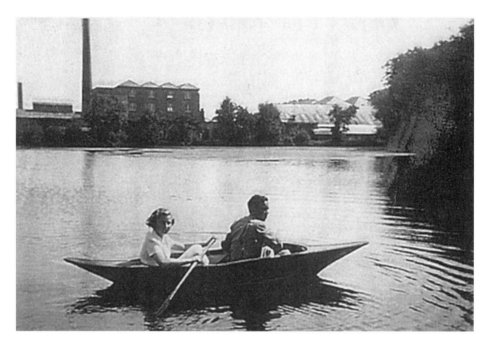

Boating on the north mill pond of Greenmount in the 1930s. This is now the site of an ESB depot at Parnell Avenue. (Courtesy of Brian and Ros Griffin)

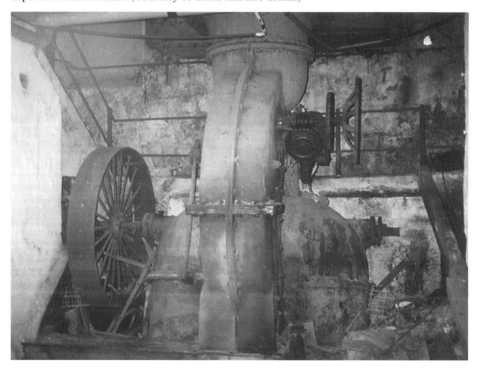

This historic double vortex water turbine is still in position in the basement of Greenmount Mill. Supplied in 1901 by Gilbert Gilkes of England for £236, it drove all the weaving machines, and was powered by the River Poddle, via the mill ponds.

THE GREENMOUNT OIL AND CHEMICAL WORKS.

→ HAROLD'S CROSS.

Dublin, 26th November 1896

Messrs The Dublin Laundry Co Ltd

Milltown

L. LE BROCQUY & CO.

Bought of L. LE BROCQUY & CO.

Order received by our Mr O'Callaghan

Conveyance your van

Terms: net 1 month Due 26th December 1896

No Claims entertained unless made immediately on arrival of Goods.

5 Gals Cylinder Oil @ 1/9		8	9	8	9

Artist, Louis le Brocquy, worked for a while in his father's oil company.

GREENMOUNT OIL REFINERY
HAROLD'S CROSS, DUBLIN
Refiners and Manufacturers of

MEDICINAL LIQUID PARAFFIN
TOILET PARAFFIN
BRILLIANTINE OILS Trade Mark:
SOLID BRILLIANTINE "GREMONTINE."
PETROLEUM JELLY (White and Yellow)
COLZA OIL

DULCECARBOL DISINFECTANT

Approved by Minister for Agriculture
Diseases of Animals Act (1894-1927).

THE GREENMOUNT OIL CO., LTD., HAROLD'S CROSS, DUBLIN

One of the company's advertisements.

GREENMOUNT & BOYNE LINEN CO., LTD.

Manufacturers, Bleachers, Dyers, and Finishers of

LINEN, UNION AND COTTON GOODS

For Home and Overseas Markets.

Amongst the goods manufactured are

Linen and Cotton Damasks, Table Cloths and Napkins, Roller Towelling, Typed and Checked Kitchen Towels, Apron Dowlas, Huck Towelling, Damask and Coloured Border Huck Towels, Checked Glass Towelling.

Checked Dusters, Sheetings, Tickens, Dyed Dress Linens, Tailors' Linings, including

Linen, Union, Cotton, and Hair Canvas Ducks, Padding, Hollands, Buckrams, Pocketing, Bleached Drills. Bleached, Dyed and Brown Ducks. Cambrics (white and dyed). Embroidery Linens. Men's Tropical Suitings.

Also Aprons, Overalls, Cotton and Linen Frocks, Shop Coats and Dungarees. Children's wear, Sheets and Pillow Cases.

WORKS:

BOYNE MILL, DROGHEDA • HAROLD'S CROSS MILL DUBLIN

IN THE IRISH FREE STATE.

Our goods can be obtained from all the Wholesale Houses in Dublin, Cork, Limerick and Waterford.

1932

The Pim family, famous Quakers, owned the Greenmount Spinning Co. for over a hundred years, and the mill supplied stock to their famous Department Store in South Great George's Street (now Castle House office block).

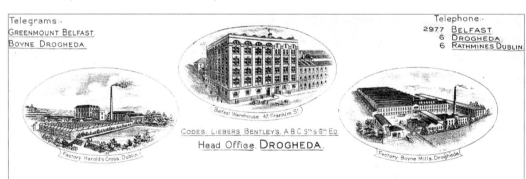

Telegrams:-
GREENMOUNT BELFAST.
BOYNE DROGHEDA.

Telephone:-
2977 BELFAST
6 DROGHEDA
6 RATHMINES DUBLIN

Belfast Warehouse, 47 Franklin St.

CODES. LIEBERS. BENTLEYS. A.B.C. 5th & 6th Ed

Head Office. DROGHEDA.

Factory Harold's Cross, Dublin.

Factory Boyne Mills, Drogheda.

GREENMOUNT & BOYNE LINEN COMPANY LIMITED.

HAROLD'S CROSS, DUBLIN

31st May, 1935.

1935 headed paper, with a sketch of Harold's Cross mill on the left, Drogheda mill on right, and Belfast warehouse in centre. (Courtesy of Seamus O'Maitiu)

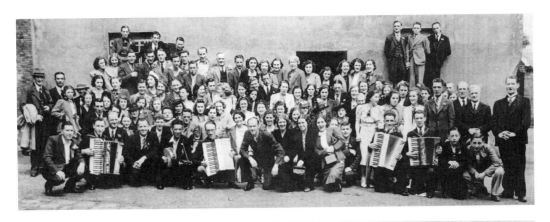

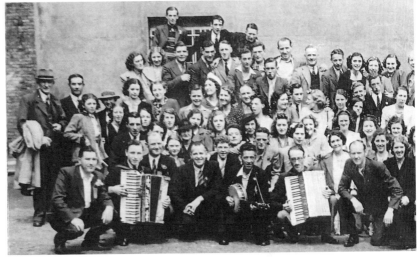

Staff of
Greenmount
& Boyne
Linen Co,
outside their
canteen,
probably
1950/60s.
Top photo
split in two.
(Courtesy of
Jack Nolan)

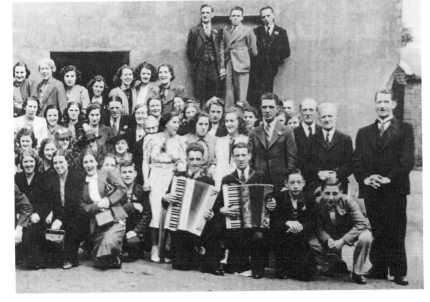

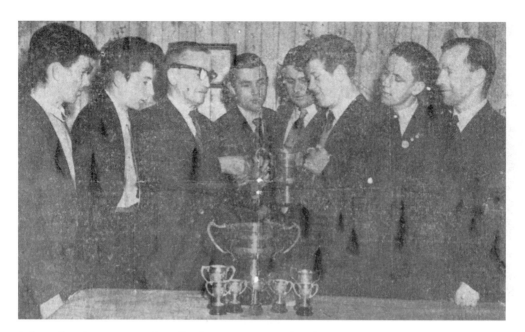

Robert Chambers presents the Billiards Cup to Jimmy Thunder in the Greenmount & Boyne Sports Club in 1957/8. From left to right: Pat Malone, Jack Nolan, Mr Chambers, John Coughlan, Herbie Coughlan, Jimmy Thunder, Charlie Hand, John Davis. (Courtesy of Jack Nolan)

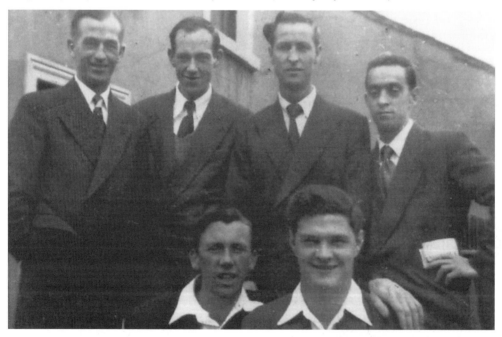

Millers Corner – the junction of Greenmount Avenue and Harold's Cross Road in the 1950s/60s. No. 42 Harold's Cross Road was occupied by Edward Lutman, foreman and worker director of the Greenmount Oil Co, and was part of the oil company site. From left to right, back row: John Davis, John McDonald, Paddy Mannering, Paddy Doran. Front row: Steve McGinn, Herbie Coughlan (Junior). (Courtesy of Anthony Carberry)

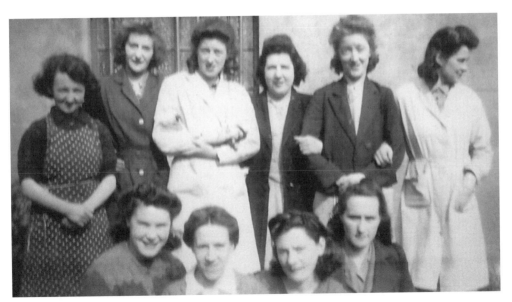

Workers in Greenmount & Boyne Linen Co. in the early 1940s. From left to right, back row: Eileen Hayden, Annie Heade, Eileen Flynn, Lily McKay, Mollie Rooney, Rita O'Donoghue. Front row: Chrissie Sherlock, Honor Carberry, Cecelia Kinsella, Maureen Sweetman. (Courtesy of Anthony Carberry)

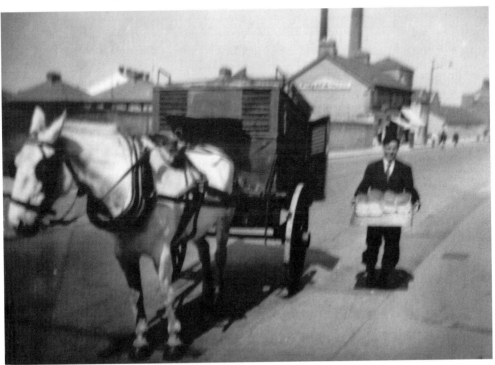

Anthony Carberry with his bread van outside the hospice entrance in 1952. The driver sat on top of the van. Note the chimneys and buildings of Greenmount Oil Co. in background beyond McCauls Medical Hall. (Courtesy of Anthony Carberry)

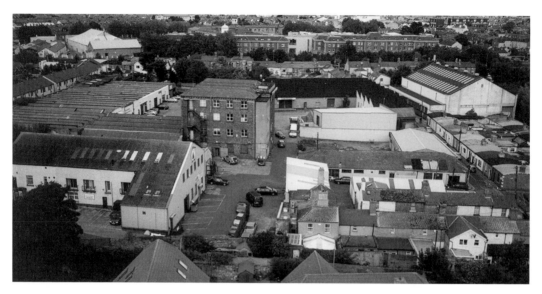

A recent photograph of Greenmount from the hospice. The big building on the centre left is the original 1807 spinning mill, and the water turbine is still in the basement under the left side. In the foreground is the new hospice convent.

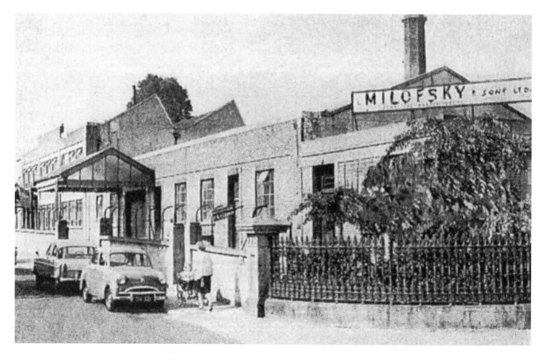

Milofsky & Sons were Jewish furniture makers in the 1960s. They operated from Mount Tallant Avenue from 1957, beside Clarnico Murray. They now supply the DIY trade, operating under the name of Woodworkers and Hobby Supply Centre. The premises was built in the 1930s for Brown and Polson, makers of cornflower, semolina, and baking powder. (Courtesy of Woodworkers and Hobby Supply Centre)

The former Clarnico Murray sweet factory on Mount Tallant Avenue, built in 1926, and known as St Pancras Works. They moved in 1973, and Eurosnax took over, making Tayto potato crisps.

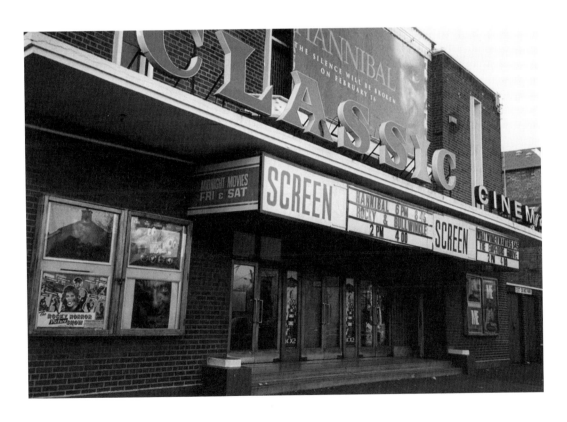

When opened in 1953, this cinema was known as The Kenilworth and only had a single screen. It later expanded to two-screens but closed in 2003, and was recently demolished.

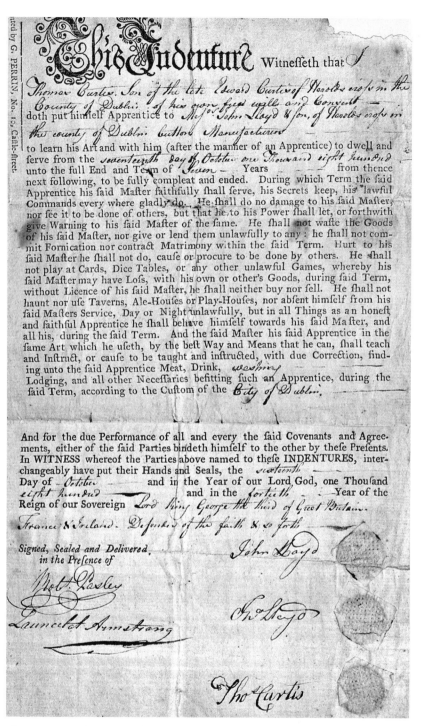

printed by G. PERRIN, No. 15, Castle-street.

This Indenture Witnesseth that I

Thomas Curtis, Son of the late Edward Curtis of Harolds cross in the County of Dublin of his own free will and Consent doth put himself Apprentice to Mess^rs John Lloyd & son, of Harolds cross in the county of Dublin Button Manufacturers

to learn his Art and with him (after the manner of an Apprentice) to dwell and serve from the seventeenth day of October one Thousand eight hundred unto the full End and Term of Seven — Years ———— from thence next following, to be fully compleat and ended. During which Term the said Apprentice his said Master faithfully shall serve, his Secrets keep, his lawful Commands every where gladly do. He shall do no damage to his said Master, nor see it to be done of others, but that he to his Power shall let, or forthwith give Warning to his said Master of the same. He shall not waste the Goods of his said Master, nor give or lend them unlawfully to any : he shall not commit Fornication nor contract Matrimony within the said Term. Hurt to his said Master he shall not do, cause or procure to be done by others. He shall not play at Cards, Dice Tables, or any other unlawful Games, whereby his said Master may have Loss, with his own or other's Goods, during said Term, without Licence of his said Master, he shall neither buy nor sell. He shall not haunt nor use Taverns, Ale-Houses or Play-Houses, nor absent himself from his said Masters Service, Day or Night unlawfully, but in all Things as an honest and faithful Apprentice he shall behave himself towards his said Master, and all his, during the said Term. And the said Master his said Apprentice in the same Art which he useth, by the best Way and Means that he can, shall teach and Instruct, or cause to be taught and instructed, with due Correction, finding unto the said Apprentice Meat, Drink, washing — Lodging, and all other Necessaries befitting such an Apprentice, during the said Term, according to the Custom of the City of Dublin. —

And for the due Performance of all and every the said Covenants and Agreements, either of the said Parties bindeth himself to the other by these Presents. In WITNESS whereof the Parties above named to these INDENTURES, interchangeably have put their Hands and Seals, the sixteenth — Day of October ——— and in the Year of our Lord God, one Thousand eight hundred ——— and in the fortieth — Year of the Reign of our Sovereign Lord King George the third of Great Britain. France & Ireland. Defender of the faith & so forth ———

Signed, Sealed and Delivered in the Presence of

John Lloyd

Matt Pasley

Launcelot Armstrong

Jno Lloyd

Tho Curtis

This apprenticeship deed was signed in 1800, between Lloyds Button factory, and Thomas Curtis. The factory was on land later occupied by St Clare's Convent. The factory started here in 1786, and later was known as Lloyd & Ridley. (Courtesy of the National Archives)

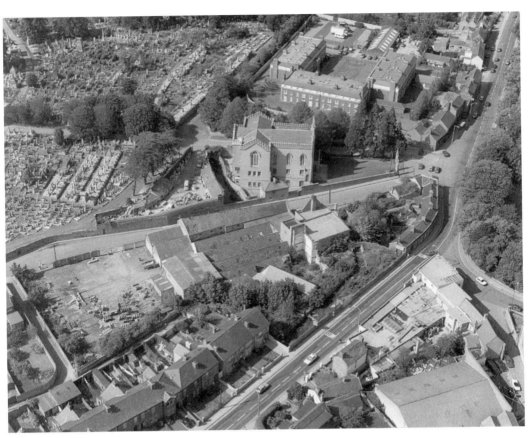

Harold's Cross Laundry started in 1894, using an old flour mill dating from the eighteenth century. You can see the River Poddle running alongside Kimmage Road, crossing the north of the mill, and running along the south side of the Anglican church. (Aerial photo courtesy of Peter Barrow)

A sketch of Harold's Cross Laundry in 1896. Note the water wheel which drove the machines. Mount Argus Road is on right. (Courtesy of the National Library)

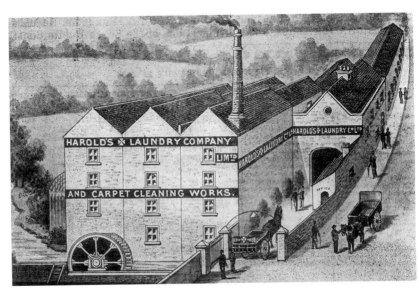

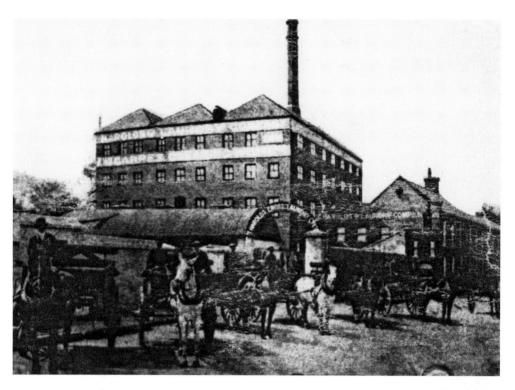

A company advertisement for Harold's Cross Laundry, showing off their fleet of delivery vehicles.

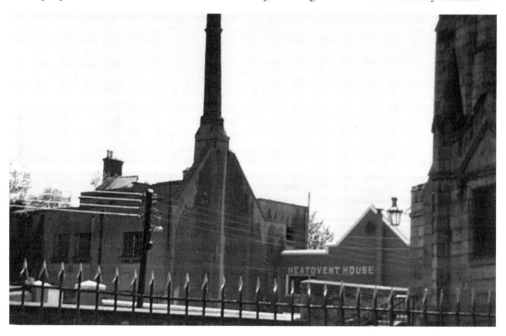

The Harold's Cross Laundry was used by a central heating suppliers (Heatovent) in the 1970s. Laurence Court houses were built on the site in the 1990s. This photograph was taken from steps of Anglican church. (Courtesy of Kevin Harrington)

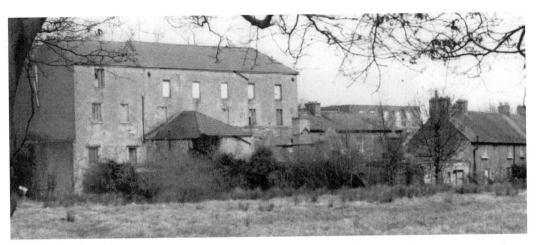

Loader Park Mill in the 1980s, from Kimmage Road, when it was owned by Mount Argus, and used as their concert hall. (Courtesy of Sean MacManamon)

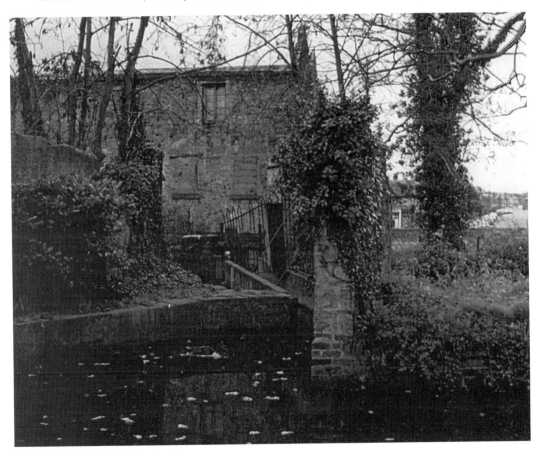

Roofless Loader Park Mill in 1986, from Mount Argus pond. The River Poddle flowed under the building, presumably operating an internal waterwheel. Note Westfield Road in the background. (Courtesy of Dublin City Council)

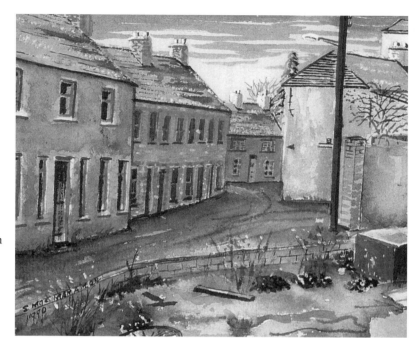

Painting of
Loader Park
cottages, by Sean
MacManamon.
The roof of the
former mill is
just visible at
top right-hand
corner.

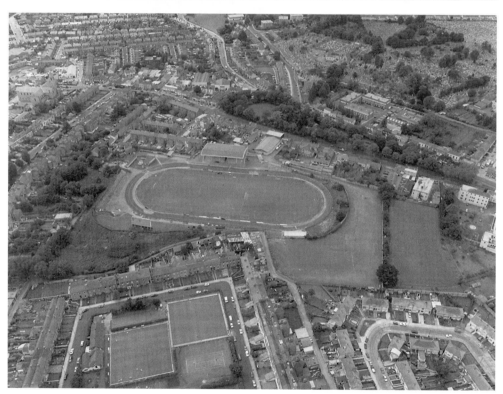

The Greyhound Stadium in the 1980s. Grosvenor Square can be seen at the bottom left, while St Clare's convent is centre right and Drummond Square bottom right. (Courtesy of Peter Barrow Photography)

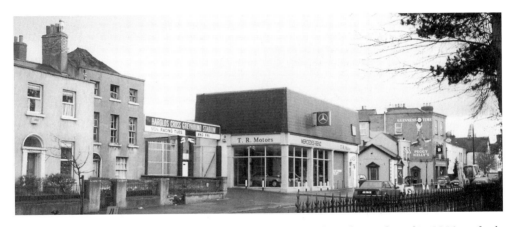

This photograph was taken prior to building of new Greyhound Track grandstand in 2001, and sale of land for Leinster Park housing. The house on the left of the Track entrance was later rebuilt. Ted Murphy, father of broadcaster, Mike, had a garage on the right-hand side of the entrance in the 1960s and 1970s, adjoining Corrigan's Grocers. The garage featured in 'The Live Mike' in 1980. Flanagan's/Peggy Kelly's pub is on the right.

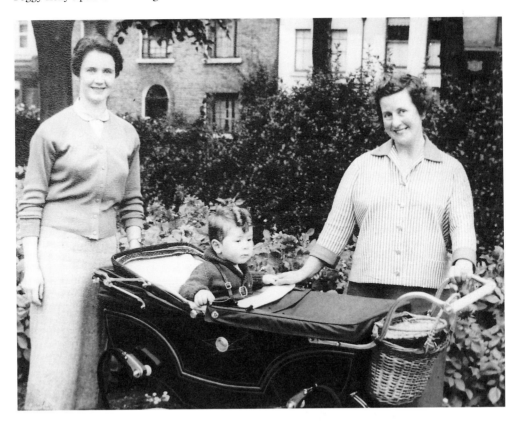

Joan Smith on the left, with baby Ronnie, and Mary Brimcombe, in Harold's Cross Park in 1958. In the background is Flanagan's pub on the right, and Corrigan's Grocers on the far left. The three houses were later demolished for a side extension to the pub, and a car park. Corrigan's and Murphy's Garage became the present T.R. Motors. (Courtesy of Jim and Joan Smith)

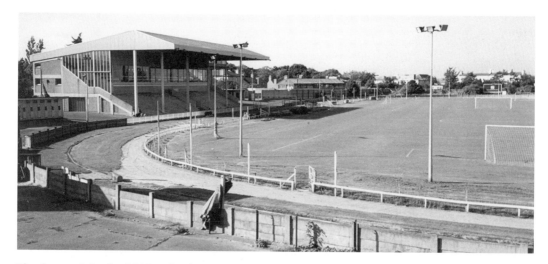

The dog track in the 1990s. The dog track was started by private individuals in 1928, and was taken over by Bord na gCon in 1970, who built this grandstand in 1978. Note the goalposts, used by Shelbourne Football Club on some occasions in the 1980s. O'Connor's Jewellery Manufacturing can be seen in centre rear (right of the grandstand).

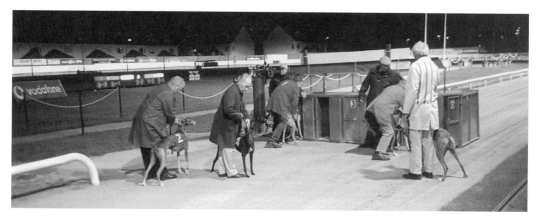

The new sand dog track, with dogs being coaxed into the starting boxes. An imitation hare is propelled along the metal track on the right.

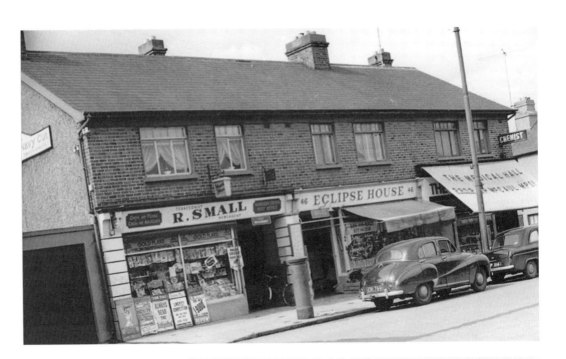

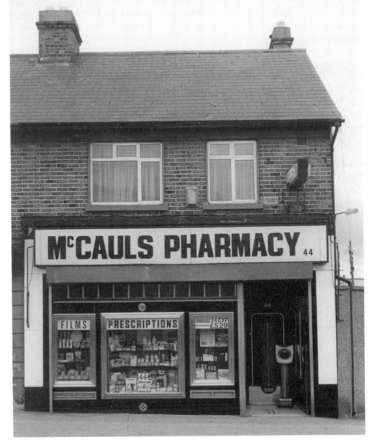

Right and above: The corner of Harold's Cross Road and Greenmount Avenue. Rathmines Public Utility Society built these shops and houses in 1930. The McCaul family traded from 1948 to 1995. In those days, all photos were processed by chemists. (Courtesy of McCaul family)

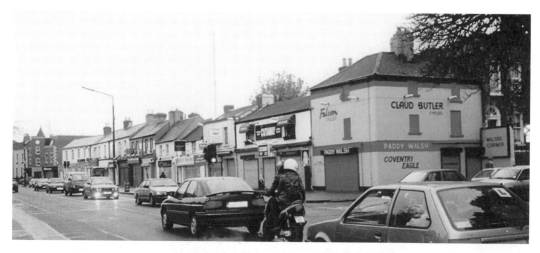

The three-storey Paddy Walsh Cycles was at the top of the park, opposite the Tree of Knowledge, both of which are now gone.

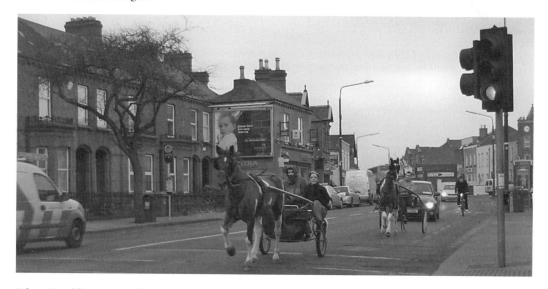

Life in Harold's Cross is still very leisurely, with time for harness racing exercises.

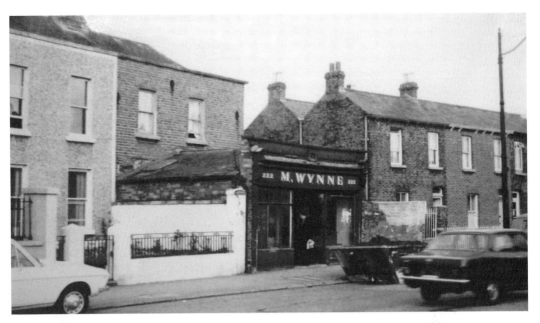

Mountain View Avenue was between Wynne's grocery shop and Shamrock Terrace. Wynne's was completely rebuilt for another use within the last twenty-five years. The left house on Shamrock Terrace was the Dispensary (public doctor and pharmacy). Next was the house of Billy Prendergast, sacristan in the Rosary Church, then another house, and finally Murdock's hardware shop. Shamrock Terrace was acquired by Harold Engineering in the 1970/80s. Concannon's bakery was the start of the main terrace of shops, ending with Paddy Walsh Cycles. (Courtesy of Seamus Whelan)

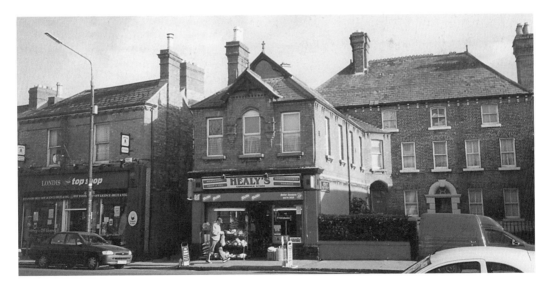

Londis was formerly run as a family grocer named Cooney's. Beside Healy's Grocery is an eighteenth-century house, used as a girls orphanage ('Birds Nest') from the 1860s to the late 1930s, and run by the Plymouth Brethren. Before that, the house was owned by the Allen family, famous Quakers, who are still active today in culinary circles.

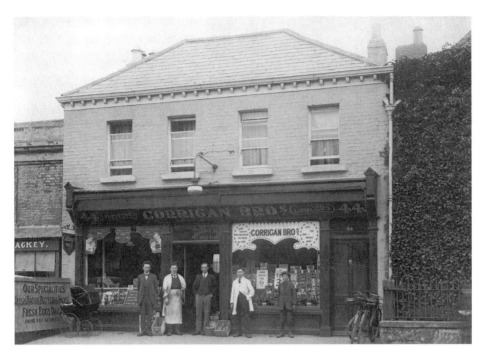

No. 44 Harold's Cross, later 155. From left to right: Jim Corrigan, Andrew Corrigan, Bill Corrigan, Frank Hyland (van driver), William (messenger boy). This photograph probably dates from the early twentieth century.

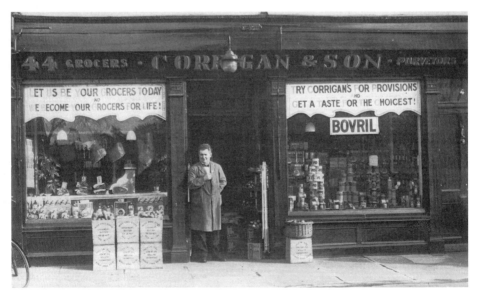

Andrew Corrigan standing in the doorway of his shop. The bacon, butter and cheese were in the left part of the shop, while groceries were in the right side. Note the chests of vegetables, which are marked 'Irish Free State Creamery Butter'. Ned Murphy's garage was to the left. Both sites are now occupied by TR Motors, Mercedes dealers. This photograph probably dates from the mid-twentieth century.

Broe Headstones was located at the corner of St Clares Avenue until recent years. Robins Headstones was located opposite the Rosary Church, at the corner of Tivoli Avenue. Various members of the Crowe family of stone carvers, operated from Emmet Street, and from Thomas Street.

Jimmy Delaney in his famous cycle and motorcycle shop beside Emmet Bridge. The family business started here in 1919, and is still going strong.

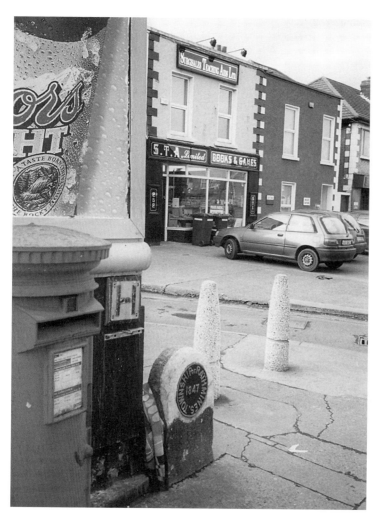

A 1847 boundary marker for Rathmines Township at the corner of Harold's Cross Road and Tivoli Avenue. Robins Headstones was behind the left hoarding and postbox. Immediatly behind Robins was a Tayto factory.

Rosie O'Grady's pub is in the centre of this scene, and Holy Rosary Church on right. Doherty's Garage was to the left of Rosie O'Gradys.

Deveney's was a family grocer opposite the Anglican Parochial Hall (now Century House). Immediately behind was a very old house called Cruz del Campo. Both were demolished in 2004 to make way for apartments.

Cruz del Campo visible when Deveney's shop was recently demolished.

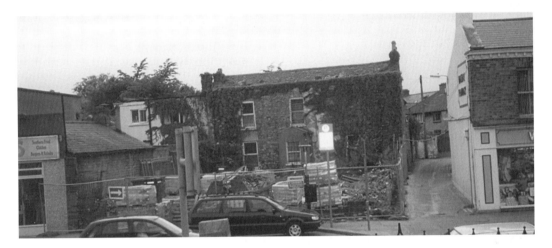

The rear of Cruz del Campo, with Fitzpatrick Cottages on right. The pinnacle of Century House can be seen on the left.

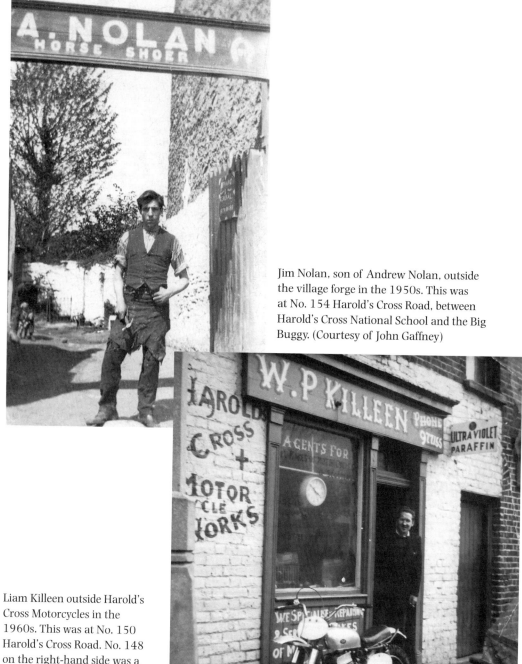

Jim Nolan, son of Andrew Nolan, outside the village forge in the 1950s. This was at No. 154 Harold's Cross Road, between Harold's Cross National School and the Big Buggy. (Courtesy of John Gaffney)

Liam Killeen outside Harold's Cross Motorcycles in the 1960s. This was at No. 150 Harold's Cross Road. No. 148 on the right-hand side was a shoe repair shop, and both No. 148 and No. 150 comprised the Big Buggy, a former militia barracks, now Hall Electrical. (Courtesy of Jim and Joan Smith)

3

CHURCHES AND
SCHOOLS

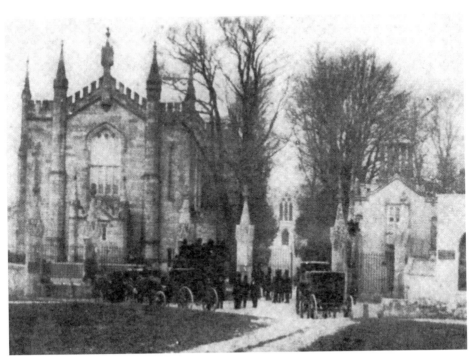

The entrance to Mount Jerome cemetery, 1890s. On the extreme right is Harold's Cross National School, which was previously a Penal Catholic Chapel from 1798 to 1833, and still showing a lancet-style window. The village green has not yet been enclosed by railings to create a Park. (Courtesy of Joyce Leach)

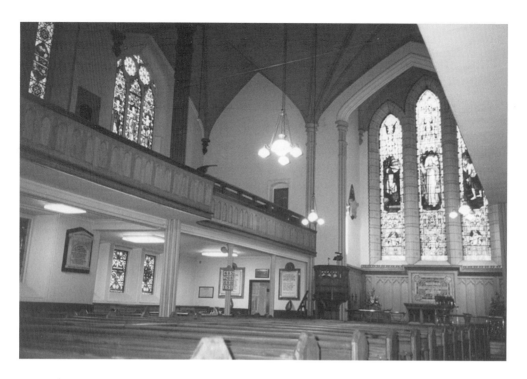

Above and below: Harold's Cross Anglican church was built in 1838, and the basement was used as a Protestant National School. The church closed in 2001, and in 2003 re-opened as the Russian Orthodox church, after the pews were removed. The Parochial Hall, at the corner of Leinster Road West, dates from 1882, and has now been converted into offices

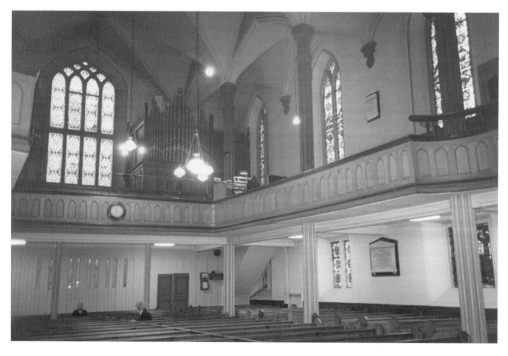

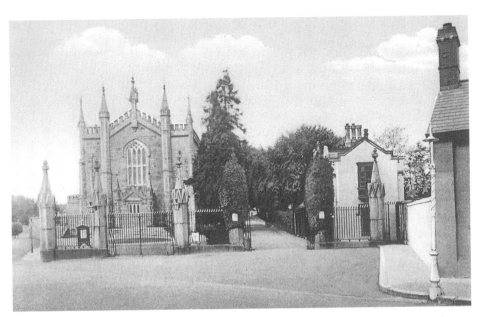

An early twentieth century postcard of the Anglican church. Note the Harold's Cross National School on the extreme right (now Hall of Lights). (Courtesy of Seamus Kearns)

The Protestant orphanage in 1886 (founded in the 1860s). The building still stands beside Healys shop, and dates from the mid-eighteenth century.

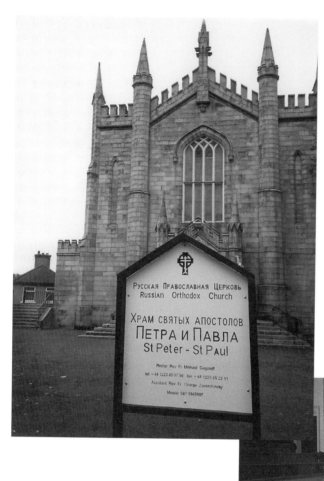

РУССКАЯ ПРАВОСЛАВНАЯ ЦЕРКОВЬ
Russian Orthodox Church

ХРАМ СВЯТЫХ АПОСТОЛОВ
ПЕТРА И ПАВЛА
St Peter - St Paul

Rector Rev Fr Michael Gogoleff
tel + 44 1225 85 87 92 fax + 44 1225 85 22 11
Assistant Rev Fr George Zavershinsky
Mobile 087-9845907

The former Anglican church is now the Russian Orthodox church. The pews are gone, since the congregation stands for the entire long service. The organ is never used, as plain chant choirs are part of the tradition (and a joy to hear).

Consecration of Russian Orthodox church on 9 February 2003. Note the lovely icons on the screen concealing the altar (regarded as a sacred place). Women still wear head scarves.

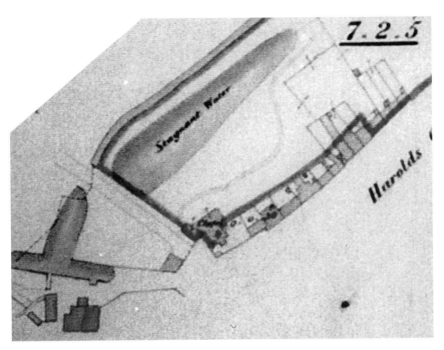

Penal Catholic Chapel beside entrance to Mount Jerome House (home of John Keogh) in 1810. The chapel opened in 1798 in an old cottage and was converted into Harold's Cross National School in 1833. Note the mill at the bottom left (later the Harold's Cross laundry). (Courtesy of Lord Meath)

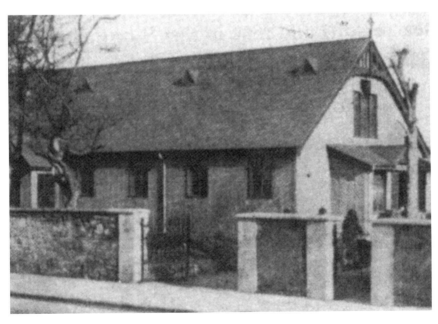

The 'Tin church' in 1935, on the site of the Holy Rosary Church, which was opened in 1938. This prefab church came from Foxrock, and went on to Merrion for a short period.

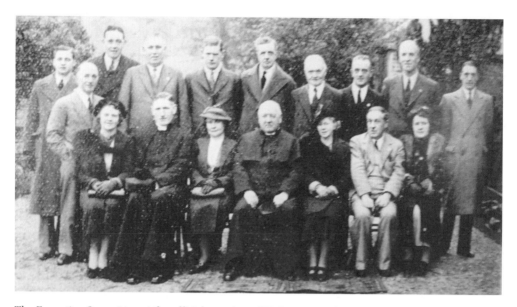

The Executive Committee at the official opening of Holy Rosary Church in 1938. From left to right, front row: Mrs Hogan, Fr Crean, Mrs Purcell, Fr McGough (PP), Mrs Hanglow, J.J. Clinton, Mrs Stobie. Back row: V. Stewart, F. Purcell, J.B. Moore, T. Casey, P. O'Byrne, Dr O'Reilly, J.J. Cleary, B. Soohan, C. Murray, E. Kennedy. (Courtesy of the Central Catholic Library)

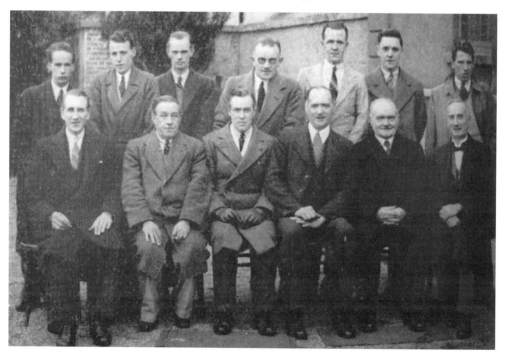

The Publicity Committee in 1938. From left to right, front row: J.J. Connolly, J.J. Clinton, W.M. Stobie, W. Carroll, J.J. Cleary, M.J. Geoghegan. Back row: J. Lynam, M. Nolan, J.C. Gaynor, B. Soohan, T. Maguire, J. Dunne, J.J. Bateson. There were also committees for Ceili, Ballroom, Sports and Entertainment. (Courtesy of the Central Catholic Library)

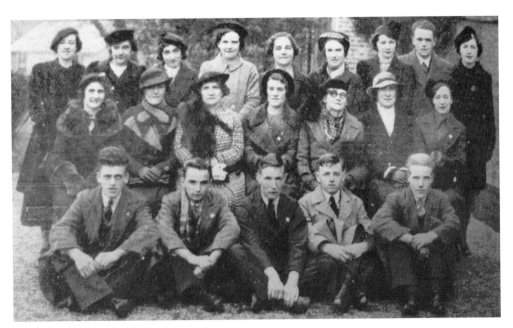

Collectors in 1938. Fronm left to right, front row: P. Curran, J. Brewster, K. Whelan, J. Briody, R. Whelan. Middle row: Miss Foley, Miss Prendergast, Mrs Costello, Miss Doyle, Miss Somers, Miss Dowling, Miss Fitzpatrick. Back row: Miss Owens, Brewster, Harvey, Hill, Condon, Keogh, Sheerin, Mr M. Doyle, Miss Fitzpatrick. (Courtesy of the Central Catholic Library)

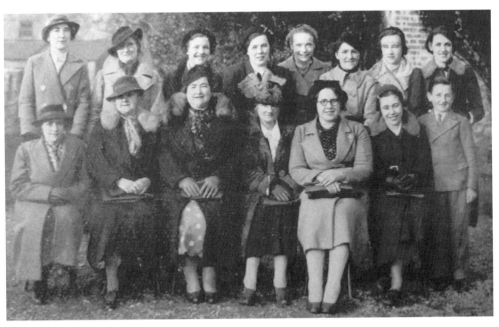

Ice Cream Stall, 1938. From, left to right, front row: Miss Ledwidge, Mrs Harding, Miss Noctor, Mrs Connolly, Mrs Farnan, Miss Johnston, Master Cooney. Back row: Miss Dowling, Miss Jermaine, Miss Keogh, Miss Conroy, Miss Byrne, Miss Keogh, Miss Byrne, Miss Johnston. (Courtesy of the Central Catholic Library)

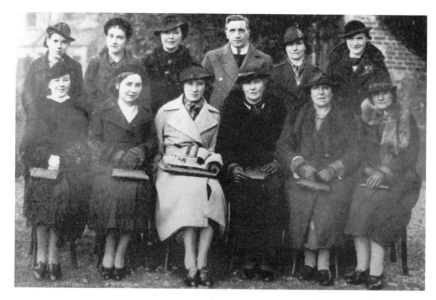

The Tulip Stall in 1938. From, left to right, front row: Miss Healy, Miss Kane, Miss Dunne, Mrs Healy, Mrs Manly, Mrs O'Loughlin. Back row: Miss Kane, Miss McGrath, Miss Fitzpatrick, Mr Armstrong, Miss Fleming, Miss O'Grady. Other stalls included, Violet, Primrose, Rose, Lavender, Daffodil, Lily of the Valley, Lilac, Carnation, Hydrangea, and Irish Industries. (Courtesy of the Central Catholic Library)

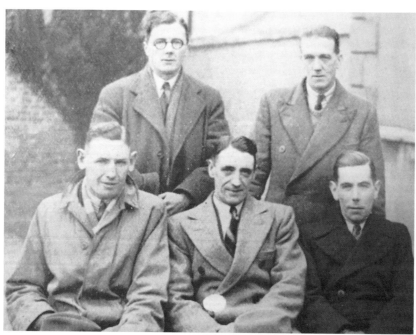

The 1938 Boxing Committee. Fronm left to right, front row: Garda Jim Brannigan, Corporal E. Kennedy (Promoter), D. Fitzsimons. Back row: W. Ryan, J. Comerford. 'Lugs' Brannigan was famous for sorting out all the 'corner boys' and 'gurriers' for miles around. (Courtesy of the Central Catholic Library)

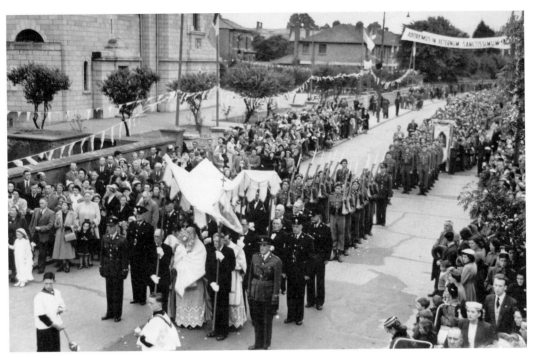

A procession passing the Holy Rosary Church in May 1957. A big banner across the road proclaimed 'O Sacrament Most Holy'. The guard of honour comprised, Superintendent J. O'Sullivan, Sergeant Tom Maher, and Garda Dan O'Neill. On the right, with Inspector Kirby, is Sergeant O'Connell, and Sergeant Bourke is on the left. (Courtesy of Oliver Maher).

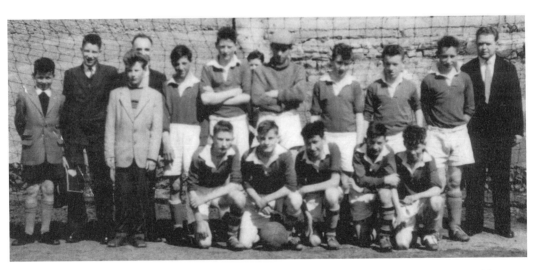

'Our Lady of the Rosary' Football Club (OLOR) in 1960. It was organised by Fr Browne. (Courtesy of Anthony Carberry)

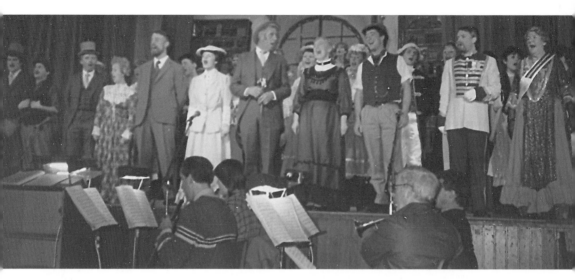

Harold's Cross Musical Society in the John Player Theatre on the South Circular Road, performing *My Fair Lady*. From left to right: Paul Heffernan, Mario McCann, Paul Laycock, Marie Gallagher, Gerry O'Brien, Jean Byford, -?- , Eva Fitzpatrick, Brendan Regan, Dan O'Connor, Eva Bruce.

Harold's Cross Musical Society perform *Viva Mexico*, with Carmel Lyons (left) and Eva Fitzpatrick, singing their hearts out. May Spinks (Auntie May) was the founder (1967) and musical director, and Josephine Scanlon was the producer. Rehearsals often took place in May's house in Westfield Road, and shows were performed in the Rosary Hall, behind present-day Kenilworth Motors.

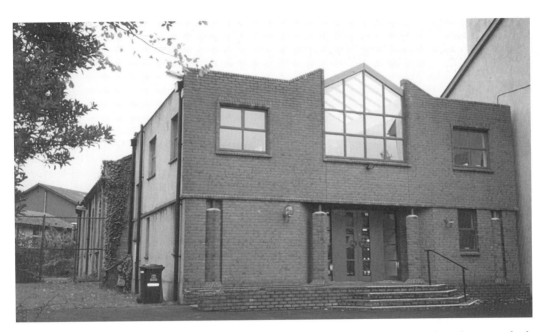

Jewish Progressive Congregation, No. 7 Leicester Avenue, at the corner of Kenilworth Square, built in 1948, with 1992 front extension.

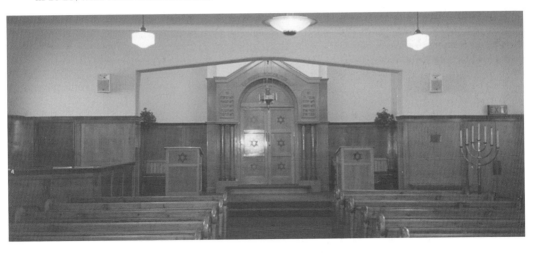

The interior of the Jewish Progressive Congregation. Women and men mix, so there is no balcony.

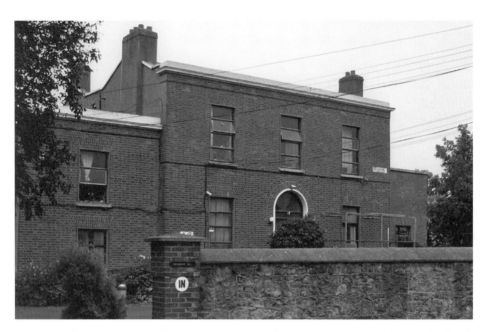

Denmark Hill, retirement home for Jews, on Leinster Road West, started in 1950, but recently closed, when the residents moved to Stocking Lane in Rathfarnham, sharing premises with the Quakers.

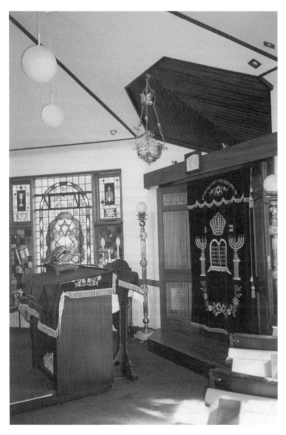

Small synagogue inside Denmark Hill Retirement home. The altar/ desk is called a Bima, from which prayers are led.

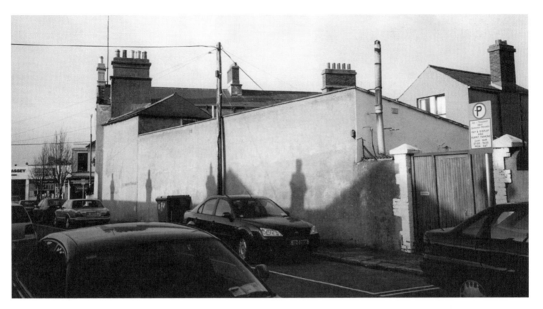

Machzikei Hadass synagogue at rear of No. 77 Terenure Road North, which opened in 1968.

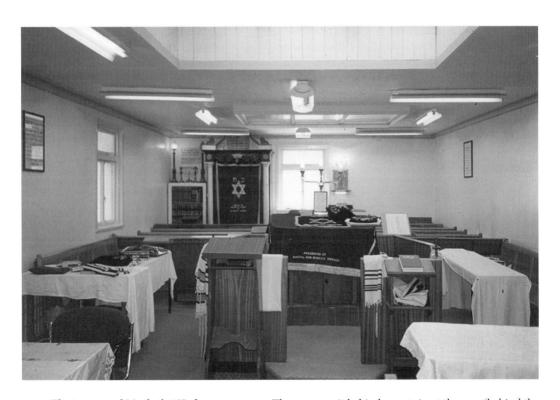

The interior of Machzikei Hadass synagogue. The women sit behind a curtain at the rear (behind the photographer). The Bima is in the centre while the Torah Scrolls are kept in the Ark (cupboard) at the rear left.

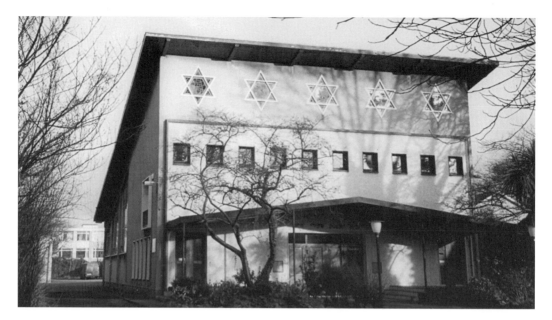

Terenure Synagogue, at No. 32a Rathfarnham Road, built in 1953.

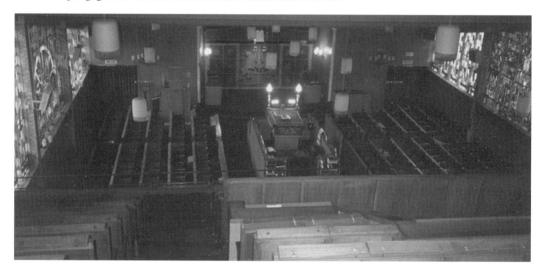

The interior of Terenure Synagogue, as seen from women's rear balcony. The 'Old City of Jerusalem' stained-glass window is on the left, while in the centre is the Bima, from which prayers are led.

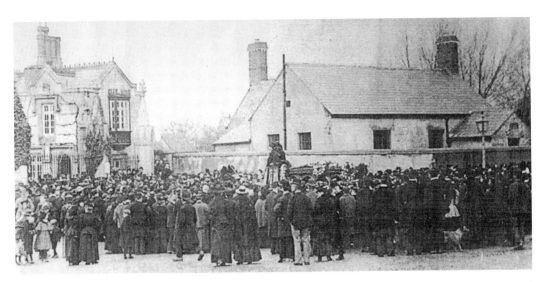

The funeral of Archbishop Plunkett in April 1897, entering Mount Jerome. Harold's Cross National School is on the right (now 'Hall of Lights' lighting showroom). (Courtesy of the Irish Architectural Archive)

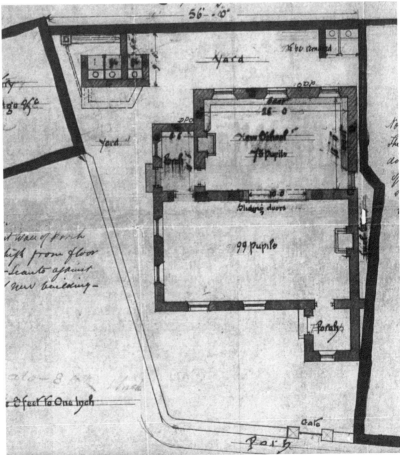

1886 plan of rear extension to Harold's Cross National School by the Board of Works. (Courtesy of the National Archives)

Harold's Cross National School, Clareville Road, opened in 1937, on part of the Carmelite convent. The girls were in the left wing, and the boys in the right wing. In 1988, the two groups amalgamated into the boy's wing. In 1993, Scoil Mologa bought the girls wing as a mixed Gael Scoil (all Irish).

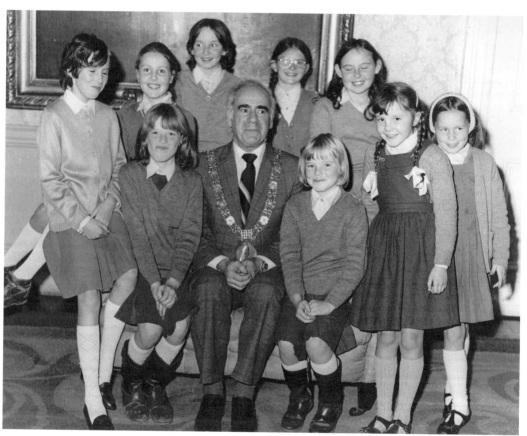

Lord Mayor Dan Browne, with the 1982/83 Nickel winners of the Lord Mayors Award Scheme, for planting trees in their school yard. Kathleen Doyle on left of mayor, and her sister, Anne Marie Doyle on right. Back row, left to right: Elaine Brennan, Joanne Hickey, -?- , Brenda Rooney, Adrienne Sullivan, Annette Cassidy, -?- . (Courtesy of Harold's Cross National School)

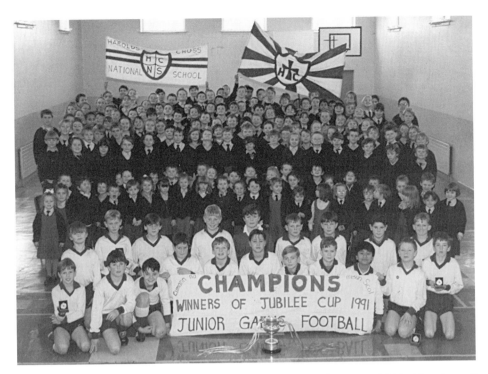

The last time the school won the Jubilee Cup in Croke Park was in 1942. (Courtesy of Harold's Cross National School)

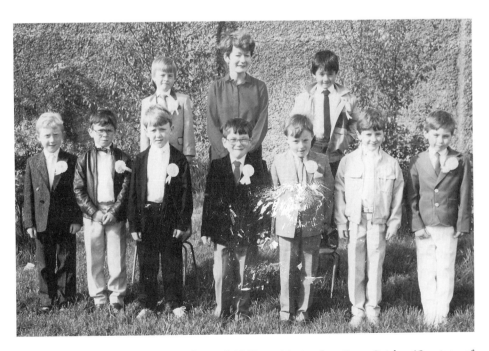

First Holy Communion group in the mid-1980s, with teacher, Joan Quirke. (Courtesy of Harold's Cross National School)

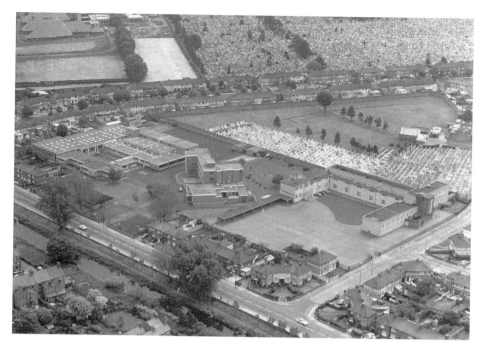

An aerial view showing Scoil Iosagain Primary School on the right (built in 1949), Christian Brothers' house in the centre (built in 1967) and Colaiste Caoimhin secondary school on the left (built in phases from 1967, and demolished in 1995). The hospice is top left and Mount Jerome top right, with Jewish cemetery beside Scoil Iosagain. (Courtesy of Peter Barrow)

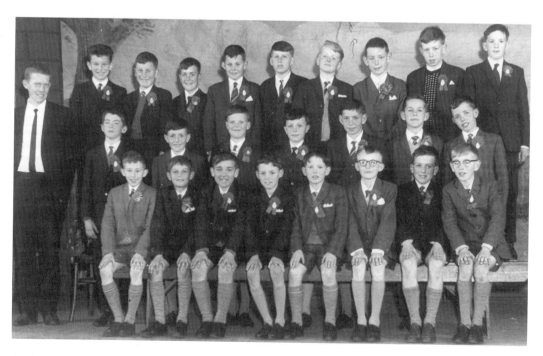

Scoil Iosagain, Aughavanagh Road: 1965 Confirmation, Class 5B, with Mr Quinn.

4

OUR LADY'S HOSPICE

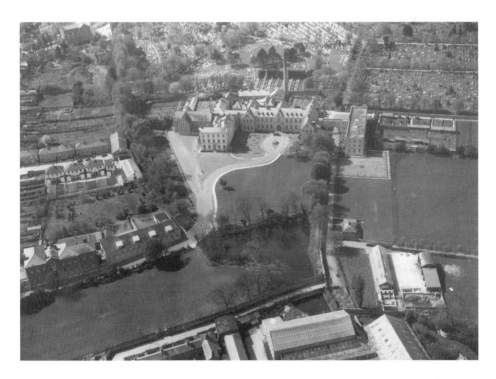

The hospice in the 1950s. On the left side is Marymount National School, including the infants on the right. Immediately to the right of the schools is a large mill pond, serving the adjoining Greenmount and Boyne Linen Co. To the right of the pond is the farmyard, including milking parlour on left, hayshed on right, and piggery at bottom. The gardener's cottage is just above the farmyard. Further to the top is the 1948 Nurses Home, and the 'hen runs' to the right of this. Mount Jerome cemetery is at the top of the photo, and Greenmount at bottom right. (Courtesy of the National Library)

This photograph shows the Lodge on the right and the oratory behind the gates with Marymount Schools next to it. Tram tracks are visible in the cobblestoned road. (Courtesy of the Sisters of Charity)

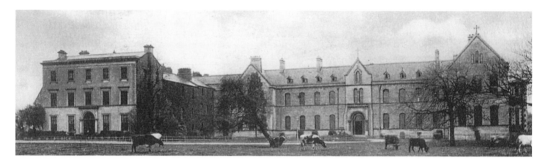

The convent on the left seems to date from 1815, while the hospice was built in 1888. The Nurses Home has not yet been built. (Courtesy of the Sisters of Charity)

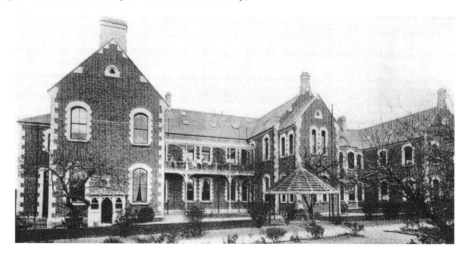

The rear of hospice was brick built (granite was only used for the front). This view is now hidden by extensions. (Courtesy of the Sisters of Charity)

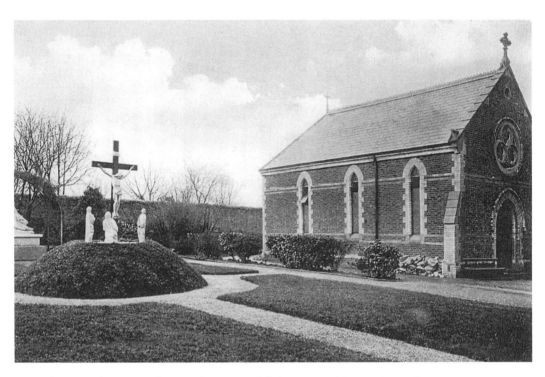

The original mortuary has now been extended. (Courtesy of Seamus Kearns)

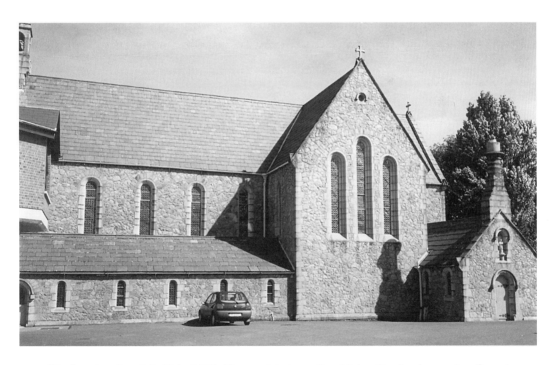

The hospice chapel, built in 1859. The sacristy is on the right, with altar boys using the entrance lobby. Cloisters on both sides of chapel allowed Easter processions to circumnavigate the chapel

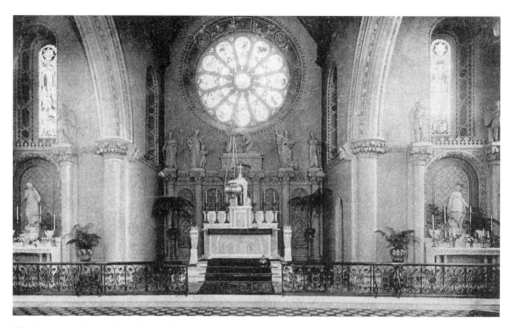

The interior of the chapel in 1914. Note the brass communion rails, and the steps up to altar for the Latin mass, with the priest turning his back to the nuns. (Courtesy of Seamus Kearns)

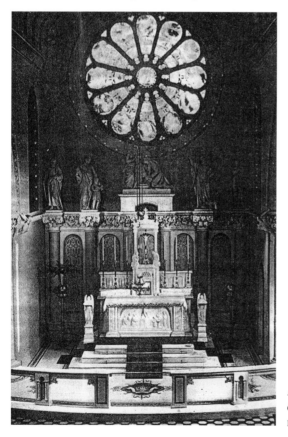

A later photo of the altar in the hospice chapel. Note the new marble communion rails. (Courtesy of the Sisters of Charity)

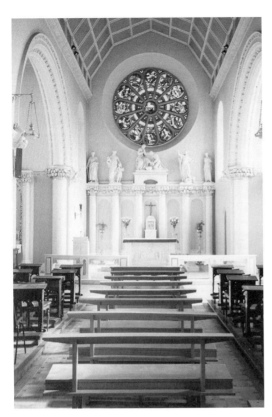

Left and below: Two recent photos of the hospice chapel, one before modernisation. The nuns had individual kneelers on a raised plinth, along both sides. The woodblock floor is now gone, and the priest faces the nuns (as a result of Vatican Council II in the 1960s).

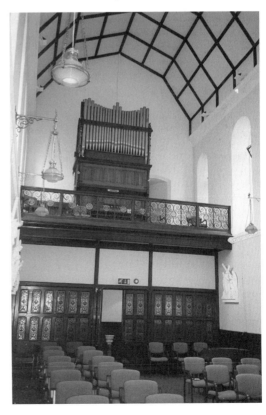

Children of Mary Golden Jubilarian, Mrs Hennessy is congratulated by Father Seán O'Neill in 1962. Sr Mary Bernard Powell, Directress from 1944 to 1963, is on the left and Madge Somerville is on the right. (Courtesy of the Sisters of Charity)

Mother Francis Joan, Rectress, congratulates the Children of Mary Jubilarians in 1962. (Courtesy of the Sisters of Charity)

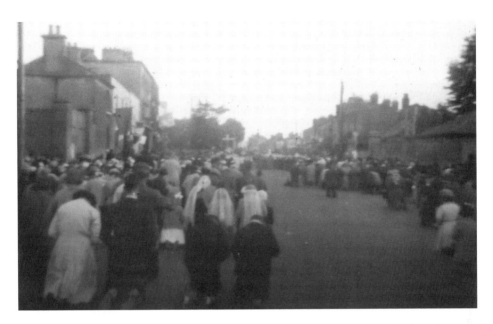

Praying on the road outside the hospice in the 1950s. (Courtesy of Anthony Carberry)

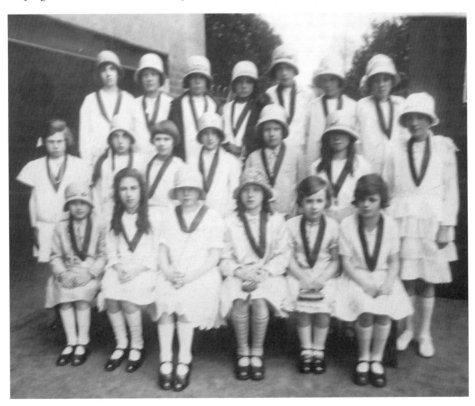

1920s: Schoolgirls at rear of the Oratory beside Marymount Schools in the 1920s. They are wearing a scapular, possibly for the Children of Mary sodality. The basement seen here under the Oratory was used for the children's bicycles. (Courtesy of Anthony Carberry)

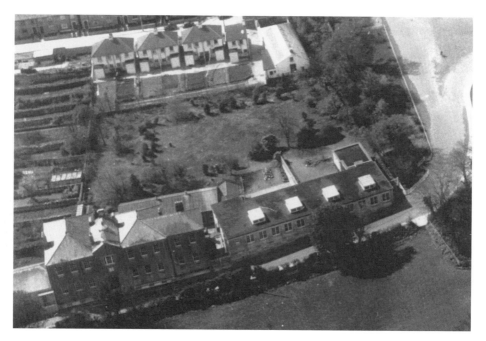

Marymount Schools in the 1950s. The primary school is on left, while the flat-roofed infants is on right. The concert hall is part visible behind the primary school. The rear field was used for primary school prefabs after 1967, when the original primary school was converted into the secondary school. (Courtesy of the National library)

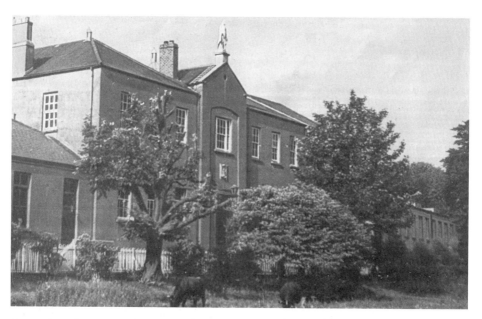

A view from the 1970s. The Oratory is on left, then Marymount Primary (built in 1851), with the infants on the far right (built in 1935). All now demolished. The big statue on top now stands on the ground in front of the old Convent. Cows can be seen grazing in the field where the tennis courts were later built. (Courtesy of the Sisters of Charity)

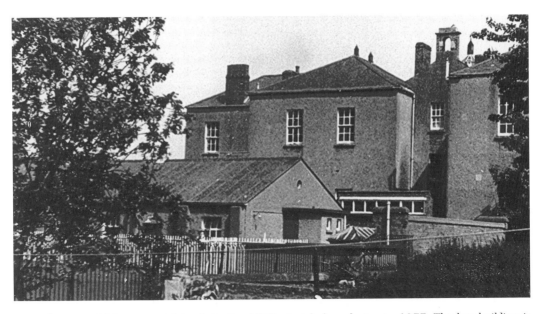

The rear of Marymount Schools in the 1970s, just before closing in 1977. The low building is Marymount Hall, the scene of many concerts and parties.

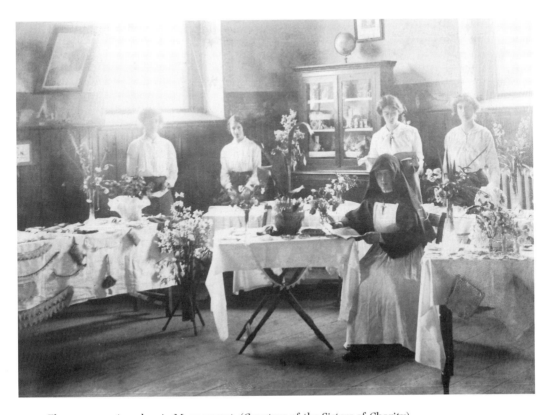

Flower arranging class in Marymount. (Courtesy of the Sisters of Charity)

From left to right: Clare Salter, Imelda Brennan, May Marsh in 1949/50. Dancing pupils of Lily O'Carroll, whose sister, May O'Carroll, was also a teacher in Our Lady's Mount (Marymount). (Courtesy of the Sisters of Charity)

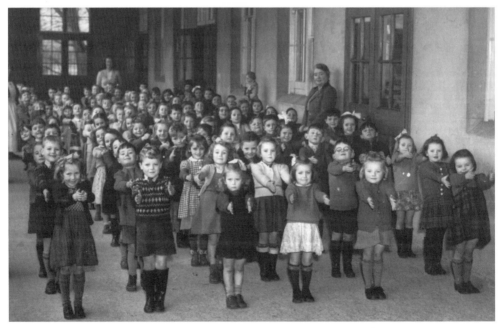

Drilling on the rear verandah of the infants school, with popular teacher, Miss Bridie Ryan, on right. (Courtesy of the Sisters of Charity)

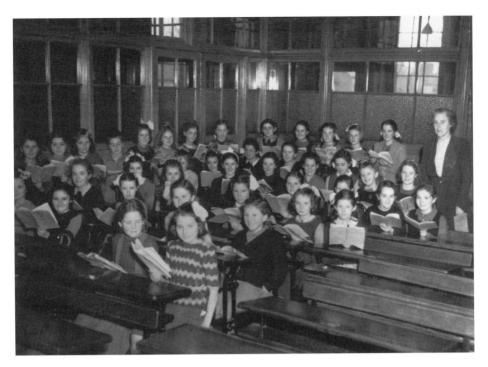

Happy infants in Marymount. (Courtesy of the Sisters of Charity)

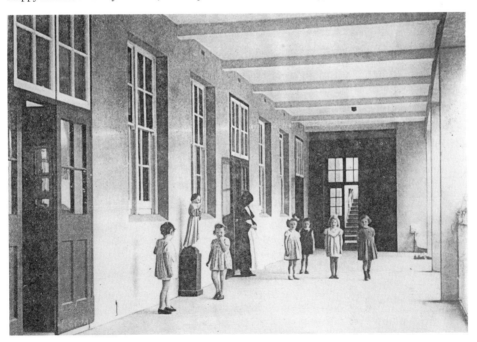

The verandah at the rear of the infants. The cast-iron stairs at the far end led into the primary School. There was a hall under the infants, used for Sales of Work (fundraising). The adult Children of Mary sometimes used the hall for their annual party, and nicknamed it the (Royal) Albert Hall. (Courtesy of the Sisters of Charity)

The primary school prefabs in the 1970s. The building to the left was a jam factory at the bottom of St Clare's Avenue and the hospice convent is behind this.

Inside Marymount Hall. This hall was often used by the Masque Theatre, run by Kevin Byrne, for operettas, such as *The Lily of Killarney*. (Courtesy of the Sisters of Charity)

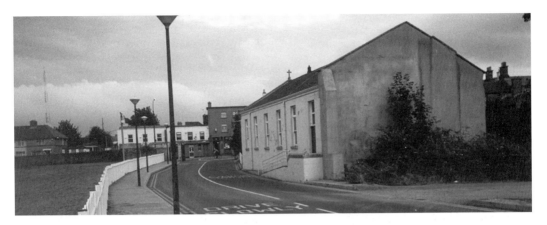

The oratory, built in 1920 by the Children of Mary Sodality, shortly before demolition in 2000. The sodality was founded by the nuns in 1860, and was wound-up in 1997.

The last meeting of the Children of Mary sodality in the hospice oratory, with Sister Collumbiere on 29 September 1997. (Courtesy of the Sisters of Charity)

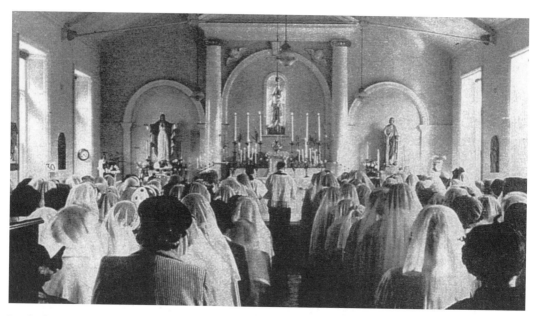

Inside the Children of Mary oratory, 1955. (Courtesy of the Sisters of Charity)

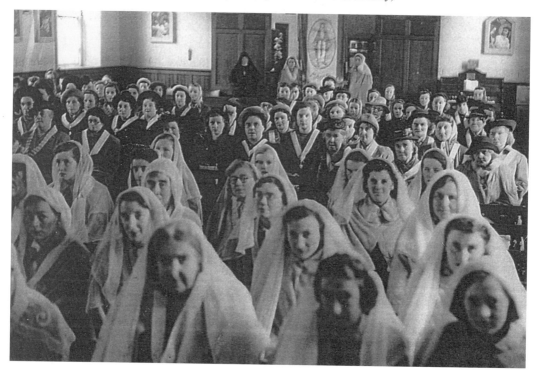

Inside the oratory, watched by Sister Mary Bernard Powell at rear, 1955. (Courtesy of the Sisters of Charity)

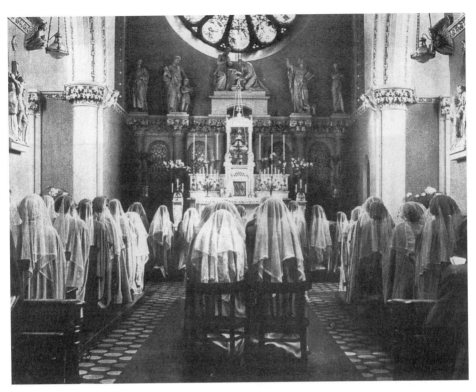

Children of Mary awaiting Benediction in hospice chapel, 1955. (Courtesy of Sisters of Charity)

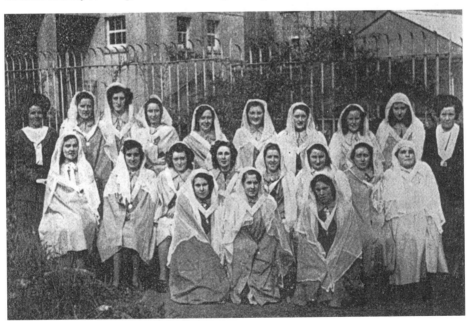

New Children of Mary consecrated, May 1948. Madge Somerville, Mistress of Candidates, is on the left while Miss K. Moore, President, is on the right. This photograoh was taken at the rear of Marymount Schools, with Hall on the right. (Courtesy of the Sisters of Charity)

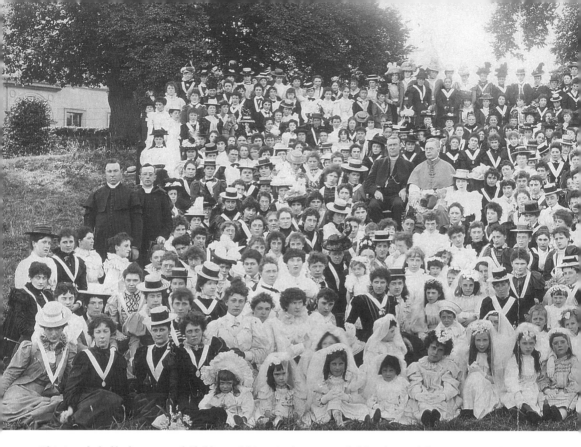

This is only half of a group of Children of Mary in the pasture field in front of the convent in 1885. (Courtesy of the Sisters of Charity)

Oppostie top: The oratory in all its glory in 1927. (Courtesy of Seamus Kearns)

Oppostie bottom: The oratory was modernised in the 1930s, and the front of the altar changed by artist Gabrielle Hayes, a famous sculptress, using white carved plaster. (Courtesy of the Sisters of Charity)

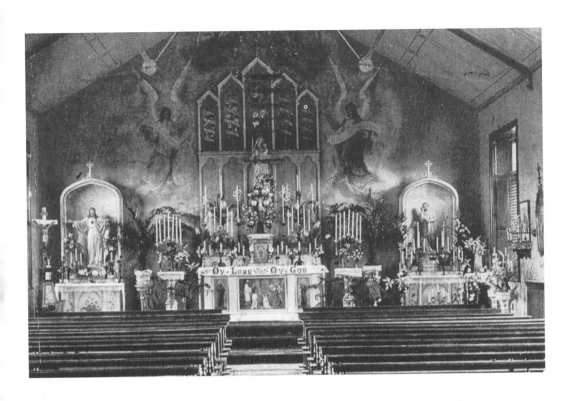

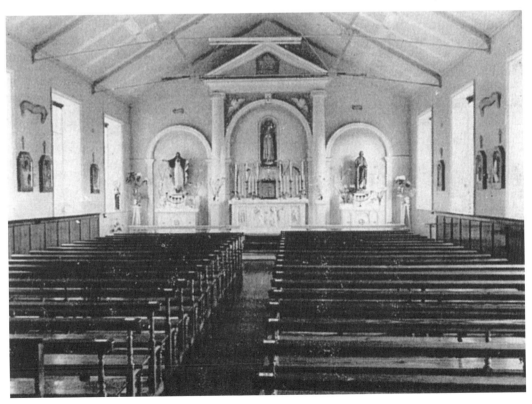

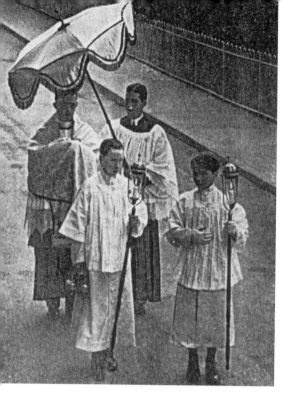

The Blessed Sacrament is carried from the hospice chapel down the avenue to Oratory in 1939. Model altar boys lead the way. (Courtesy of the Sisters of Charity)

From left to right: Fr Fenelon, Fr O'Neill, Fr Callery in 1963. All were directors of the Children of Mary Sodality. (Courtesy of the Sisters of Charity)

Council of Children of Mary 1962-3: From left to right, back row: Bella Cooke, Maura Noctor, Kathleen Swifte, Nance Moloney, Ann Byrne, May Glennon. Front row: Fr J. Fenelon, Madge Somerville, Sr Mary Bernard, Nora Browner, Fr Sean O'Neill. (Courtesy of the Sisters of Charity)

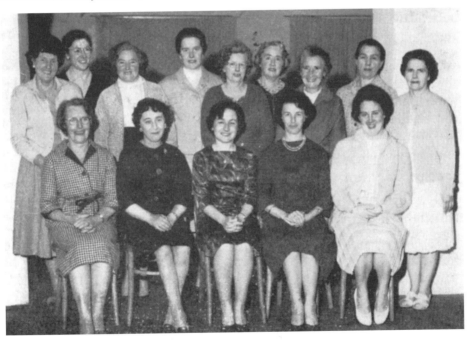

Children of Mary Social Committee 1963: From left to right, back row: E. Whelan, Vera Moiselle, Mrs Brady, M. Noctor, K. Swifte, N. Maloney, M. Glennon, M. Browner, Madge Somerville. Front row: B. Cooke, C. O'Callaghan, P. O'Reilly, P. Sheridan, E. Compton. (Courtesy of the Sisters of Charity)

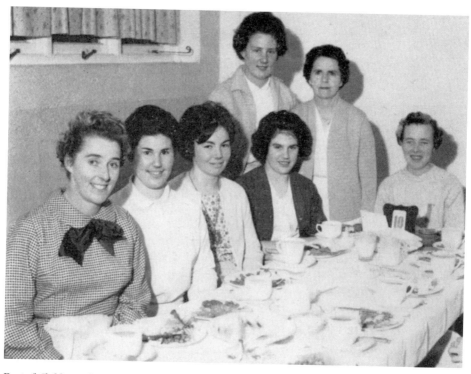

Part of Children of Mary choir, 1963. From left to right, standing: E. Compton, Madge Somerville. Seated: M. Veale, A. Morrin, M. Conlan, C. Fox, M. Finn. (Courtesy of the Sisters of Charity)

Children of Mary Sewing class, 1963. From left to right: N. Kavanagh, E. Lynch, Mrs Egan, C. Byrne. (Courtesy of the Sisters of Charity)

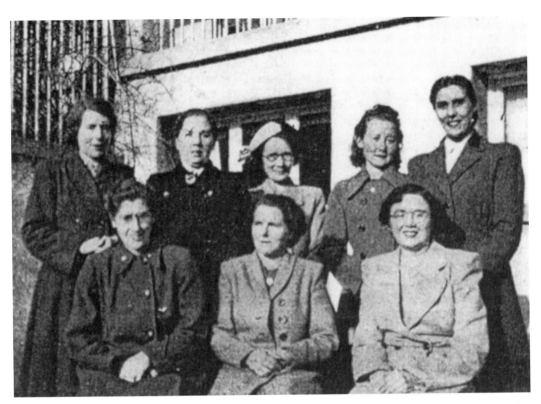

Children of Mary Council 1949-50: From left to right, front row: Vera Moiselle (Treasurer), Madge Somerville (President), K. O'Loughlin (Secretary). Back row: E. Lynch, N. Browner, M. Glennon, Una Crowe, A. Taylor. This photograph was taken in yard below the infants school verandah, outside the Albert Hall. (Courtesy of the Sisters of Charity)

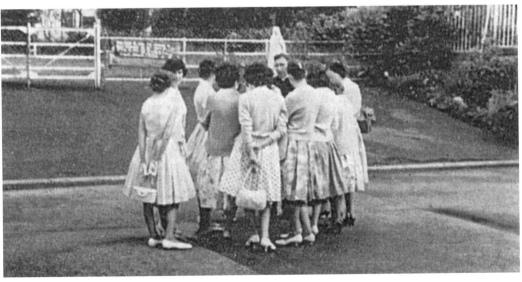

Fr Des Kenny with an admiring group of teenagers, 1960. The convent is barely visible in the background to the left. The infants school verandah is at top right. (Courtesy of the Sisters of Charity)

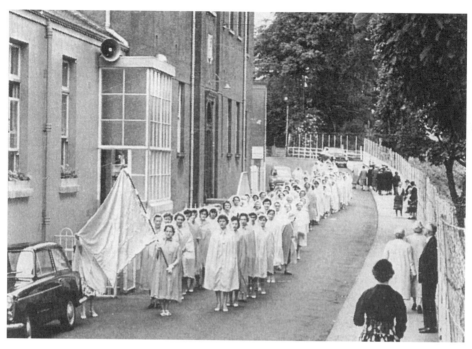

Centenary celebrations, 6 June 1960. The Children of Mary are marching towards the hospice gates, with the Oratory on the left, and Marymount Schools next in line. (Courtesy of the Sisters of Charity)

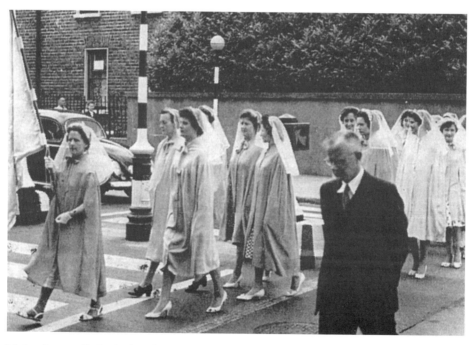

Madge Somerville leads the Children of Mary across the zebra crossing outside the hospice entrance, 6 June 1960. (Courtesy of the Sisters of Charity)

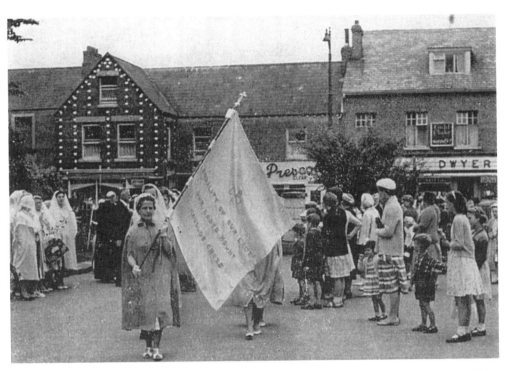

Madge Somerville leads the way into the Holy Rosary church, 6 June 1960. (Courtesy of the Sisters of Charity)

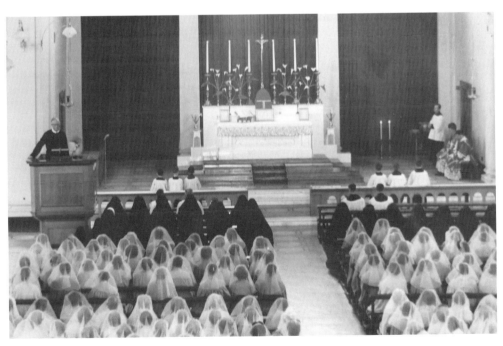

Children of Mary from Marymount celebrate Centenary in Holy Rosary Church, with sermon preached by Fr G. McDonnell, 6 June 1960. (Courtesy of the Sisters of Charity)

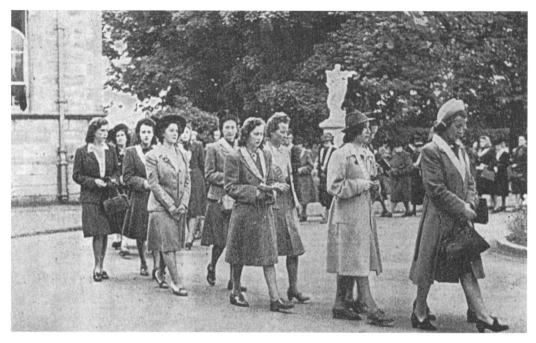

Children of Mary Sodality Day, May 1948, in front of hospice building. (Courtesy of the Sisters of Charity)

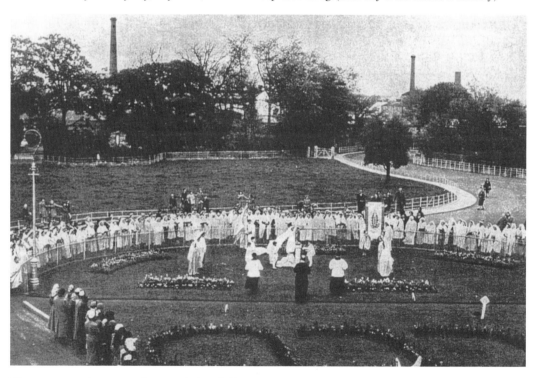

The crowning of a statue of Our Lady, by Children of Mary in front of hospice, May 1955. Note the Greenmount & Boyne chimney stack at the rear left, and two stacks for the Greenmount Oil Co. at rear right. (Courtesy of the Sisters of Charity)

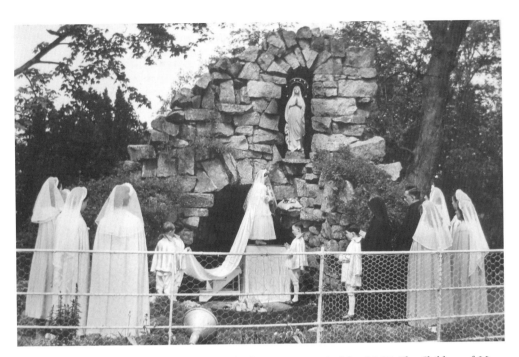

Crowning of a statue of Our Lady in the hospice grotto, in May 1957. The Children of Mary wear their blue cape and white veil, and the altar boys are dressed to kill. (Courtesy of the Sisters of Charity)

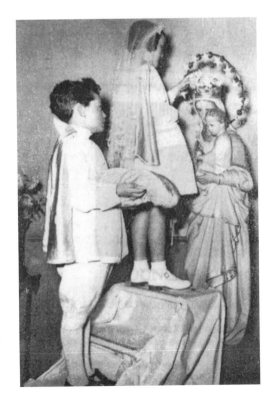

In the Institution Hall, Our Lady's hospice, a statue of Our Lady is crowned by Clare Hamill and Paul Birmingham, 1954/5. (Courtesy of the Sisters of Charity)

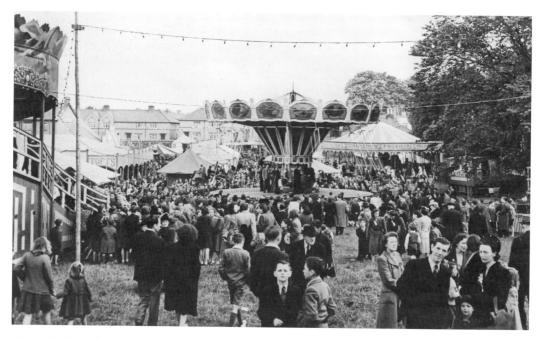

Above and below: 'Tofts Carnival' in the hospice field opposite the schools, 1948. Jim Bacon provided the music in the tented ballroom (which held 500). There was also a Ceili tent and an African tent. £7,000 was raised for the newly built Nurses Home. (*Irish Press* photo courtesy of the Sisters of Charity)

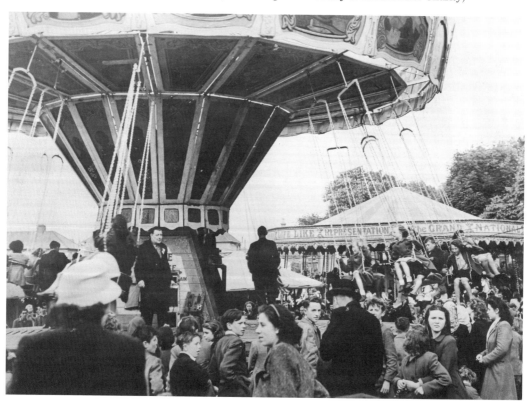

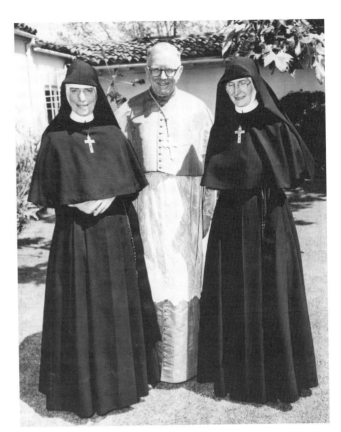

Revd Patrick Joseph Dunne,
Titular Bishop of Nara, officially
opened the 1948 carnival.
Mother Teresa Anthony Heskin
is on the right and Sister John
Fisher McSorley is on left. (*Irish
Press* photo courtesy of the
Sisters of Charity)

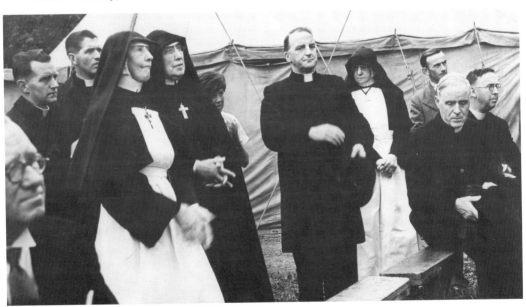

1948 Hospice Carnival. Sisters of Charity and local priests listening to the speeches, including Fr
McGough (PP). The Lord Mayor, P.J. Cahill, was also in attendance. (*Irish Press* photo courtesy of the
Sisters of Charity)

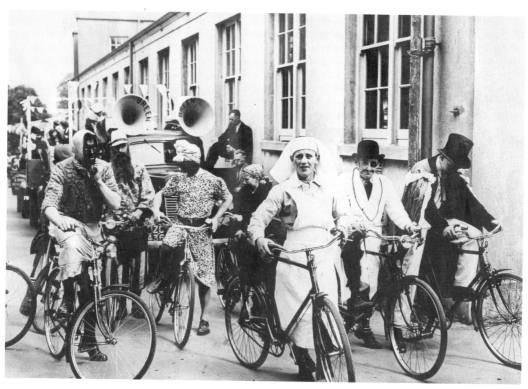

1948 Hospice Carnival, passing Marymount Infants School. Matron leads the charge. (*Irish Press* photo courtesy of the Sisters of Charity)

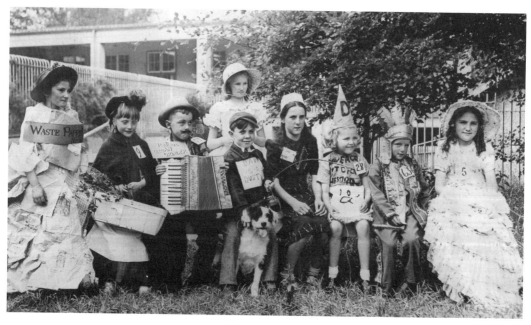

1948 Hospice Carnival. Marymount Infants verandah can be seen in the background. (*Irish Press* photo courtesy of the Sisters of Charity)

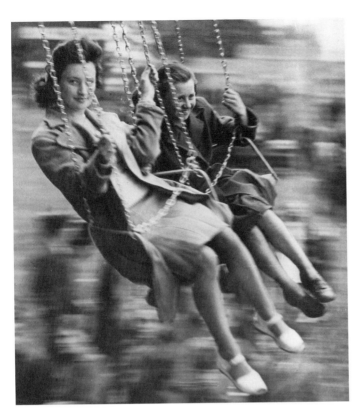

1948 Hospice Carnival.
Harold's Cross beauties on the
'chairoplanes'. (*Irish Press* photo
courtesy of the Sisters of Charity)

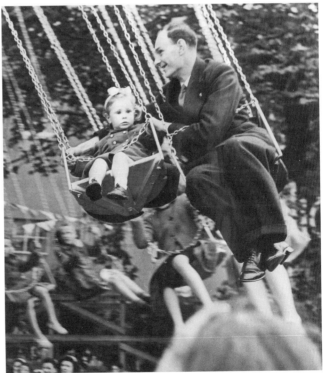

1948 Hospice Carnival. 'Isn't
Daddy very brave'. (*Irish Press*
photo courtesy of the Sisters of
Charity)

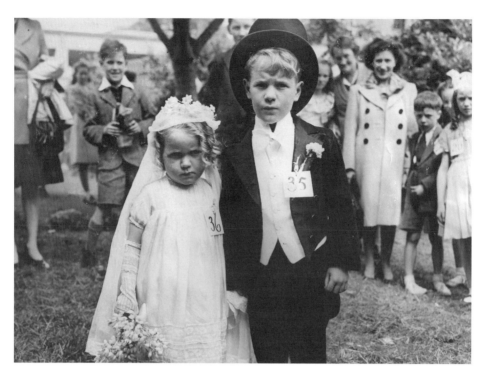

1948 Hospice Carnival. 'We don't want our picture taken!' (*Irish Press* photo courtesy of the Sisters of Charity)

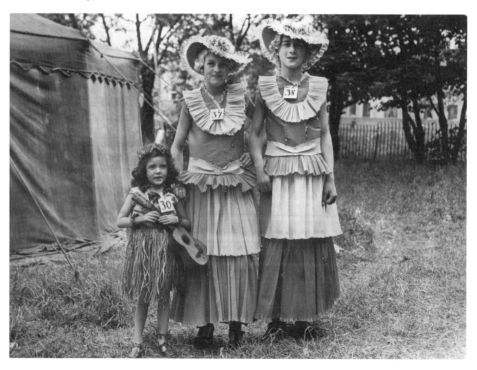

1948 Hospice Carnival. (*Irish Press* photo courtesy of the Sisters of Charity)

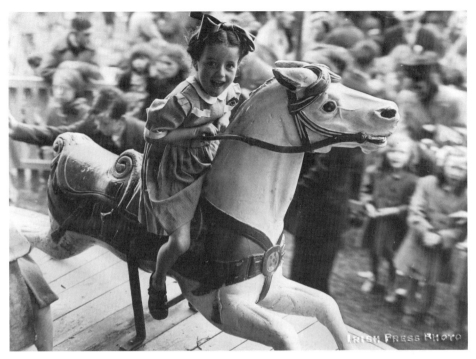

1948 Hospice Carnival. (*Irish Press* photo courtesy of the Sisters of Charity)

1948 Hospice Carnival. Newspapers do have their uses! (*Irish Press* photo courtesy of the Sisters of Charity)

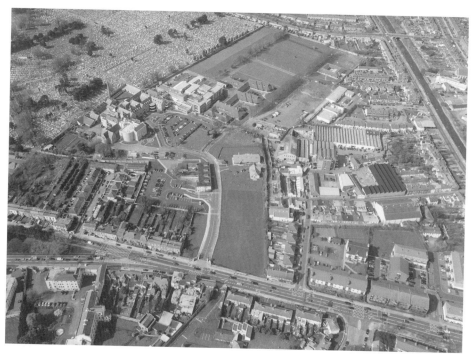

The hospice, *c.* 2004. St Clare's Convent is at the bottom left, Mount Jerome is top left, and Greenmount is centre right. The Grand Canal can be seen along top right. (Courtesy of Peter Barrow)

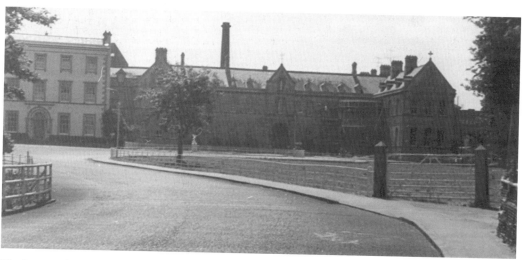

The hospice from the top of avenue, at bridge across the River Poddle, 1975. There was a small mill pond for Greenmount & Boyne Linen Co. on the extreme lower right. The field was still in use for grazing cows. Note the enclosed bridge to the right of the hospice leading to the Nurses Home.

5

RELIGIOUS COMMUNITIES

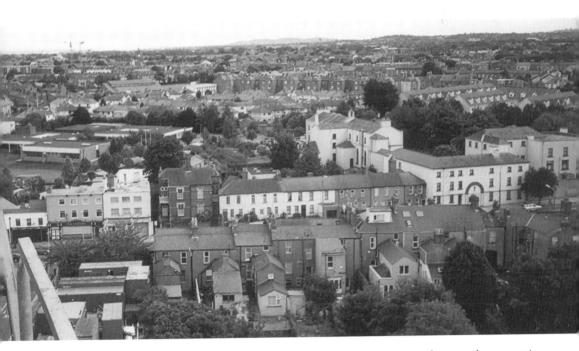

A recent aerial photo of St Clare's Convent, taken from a tower crane working on the conversion of the hospice convent into a Heritage Centre. The orphanage was the three-storey L-shaped front building, built in 1806, with the 1819 chapel behind it to the left, and then the 1816 convent. The old primary school is to the right of the orphanage, and incorporates an eightennth-century building. A school was established in the old building in 1820, but closed to the public in 1886. The school re-opened in 1951, and transferred to a new low rise building in the mid 1970s (left of the photo). Some of the priests from the Holy Rosary Church occupied the big house (No. 82 Harold's Cross Road) on the bottom right of the photo. The Lantern Inn pub is on the centre left.

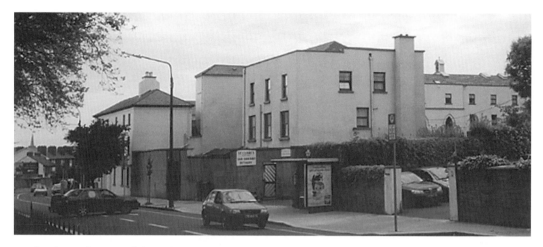

St Clare's Orphanage (left), school (centre), chapel and convent (right). The flat-roofed front extension on the school is comparatively modern. All are now closed and awaiting sale and re-development. In 2010, the nuns moved into a new three-storey convent in the grounds of the 1970s primary school. The new convent incorporates a modern chapel, which allows a small number of local residents to attend daily Mass.

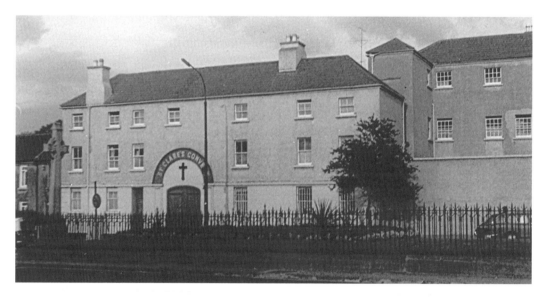

St Clare's Orphanage on left, including a vehicular archway. The eighteenth-century school can be seen on right. This picture was taken before the front extension was built.

The rear of eighteenth-century school building can be seen on left, while the rear of the 1806 orphanage is on the right (brick facade in those days). (Courtesy of St Clare's Convent)

An old postcard showing the convent (right) and chapel (left). There are rooms above and below the chapel, as a sort of disguise before Catholic Emancipation in 1829. (Courtesy of St Clare's Convent)

THE ANNUAL SERMON,

IN AID OF THE

FEMALE ORPHAN-HOUSE, HAROLD'S-CROSS,

WILL BE PREACHED IN

Francis-street Chapel,

On SUNDAY NEXT, MARCH 11th 1821, at 2 o'Clock,

BY THE MOST REV. DOCTOR MURRAY.

After which a Collection will be made for the Maintenance, Clothing and Education of

Seventy-five Female Orphans,

And at Seven o'Clock in the Evening, ANOTHER SERMON will be Preached in said Chapel,

BY THE REV. RICHARD HENRY,

For the same most useful Charity.

———————

HERE Divine Providence has prepared a place of refuge to rescue the forlorn Orphan from all the evils which threaten unprotected Innocence, and has provided her with the best substitutes for her departed Parents, in those Ladies, who, totally secluded from the world and its cares, devote themselves to the exercise of Charity, by watching over the Morals of the Fatherless and Motherless Children committed to their care, training them to habits of Virtue and Industry. In addition to those great Works of Mercy, the Guardians of the Institution have fitted up a Day School, wherein the Poor Children of Harold's-Cross and its Neighbourhood receive Instruction, and for whose improvement the religious Ladies bestow their valuable superintendance with every necessary Instruction. Your presence and support on this interesting occasion are most earnestly requested.

Donations will be most gratefully received at the Orphan-House; also, by the Most Rev. Doctor TROY, the Most Rev. Doctor MURRAY; the Rev. Gentlemen of Francis-street Chapel; W. and E. CONLAN, Esqrs.; LYNCH and YOUNG, Esqrs.; ANDREW ENNIS, Esq. High-street; J. C. BACON, Esq., and by JOHN O'BRIEN, Esq. Treasurer. No. 5, Mountjoy-square. East.

1821 notice of a Public Sermon in Francis Street chapel in aid of the Poor Clare's Orphanage in Harold's Cross. This was an annual event, attracting wealthy patrons, and noted orators. Sermons were also preached in aid of other charities throughout the year.

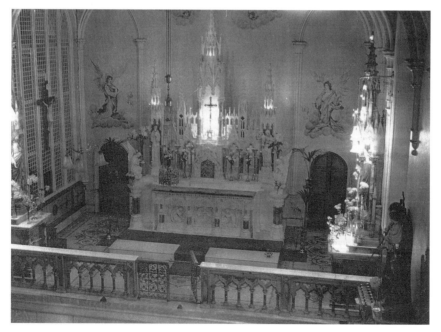

Old photo of St Clare's chapel. Behind the left screen was the nuns' private chapel. Note the right-hand side altar. (Courtesy of St Clare's Convent)

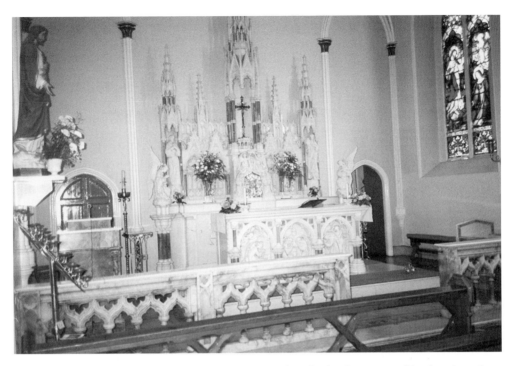

Above and below: Recent photos of St Clare's convent chapel. The Cararra marble altar dates from 1910. The stained-glass windows are now gone.

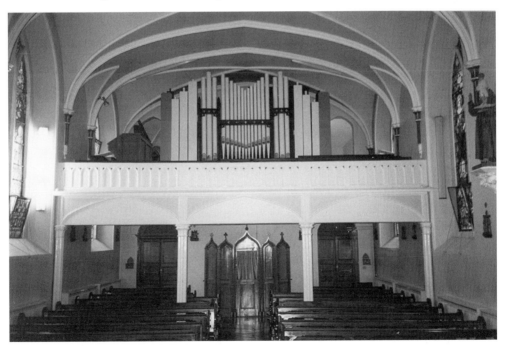

Above and below: Recent photos of the nuns' private chapel (off the main chapel) in St Clare's Convent.

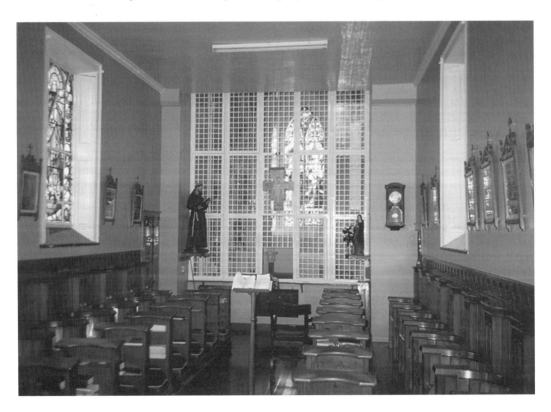

1849 Mortuary and Coffin Repository in St Clare's Convent. The lawn was the original cemetery.

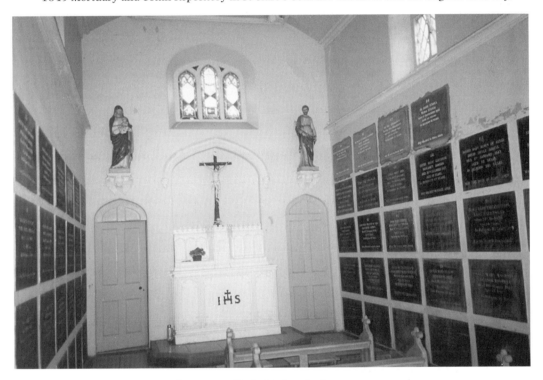

Inside St Clare's Mortuary, there is a coffin behind each plaque.

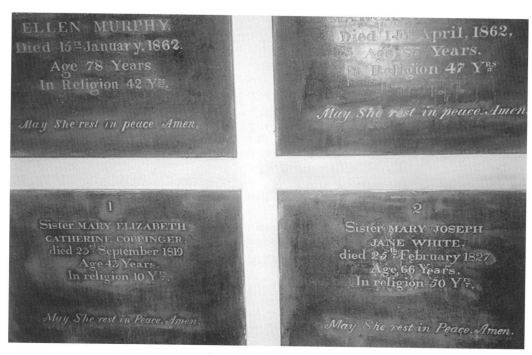

ELLEN MURPHY,
Died 15ᵗʰ January, 1862.
Age 78 Years
In Religion 42 Yᴿˢ.

May She rest in peace Amen.

Died 14ᵗʰ April, 1862,
Age 87 Years.
In Religion 47 Yᴿˢ.

May She rest in peace. Amen.

1

Sister MARY ELIZABETH
CATHERINE COPPINGER,
died 23ᵗʰ September 1819
Age 43 Years,
In religion 10 Yᴿˢ.

May She rest in Peace. Amen.

2

Sister MARY JOSEPH
JANE WHITE,
died 25ᵗʰ February 1827
Age 66 Years,
In religion 50 Yᴿˢ.

May She rest in Peace. Amen.

Sister Mary Elizabeth (Catherine Coppinger), who died in 1819, was the first member of the Harold's Cross convent to be interred in the mortuary.

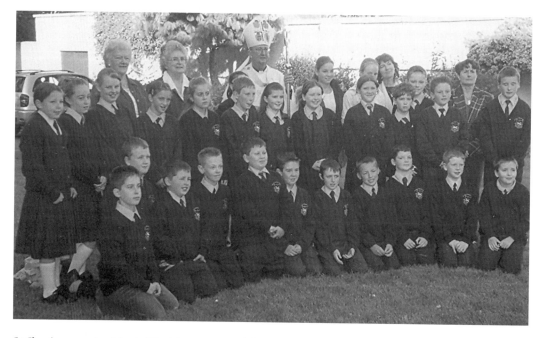

St Clare's convent celebrated the bi-centenary of their presence in Harold's Cross with a special Mass in the Holy Rosary Church in 2004. The photo shows the St Clare's Primary School choir behind the Rosary Church, with Archbishop Diarmuid Martin, and Abbess Sr Patricia Rogers.

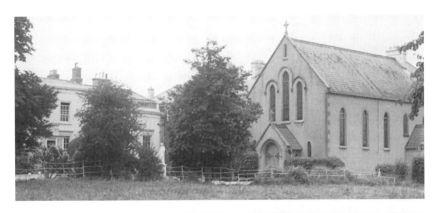

St Teresa's Monastery, Mount Tallant Avenue, in 1971. It was run by the Carmelite nuns, an enclosed order. They arrived in Harold's Cross in 1892, after buying an old house, called Mount Tallant. The chapel was built in 1894. In 1972 they sold to the Franciscan Missionaries of Mary, who only stayed a few years, before selling to a developer, who built houses, The Cloisters. (Courtesy of Carmelite Convent, Delgany)

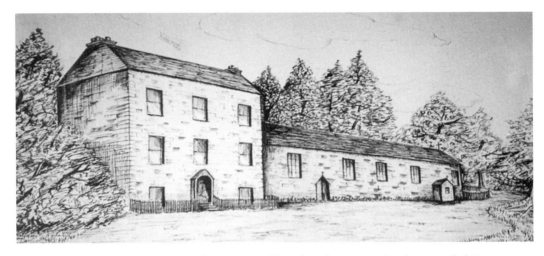

The Passionist fathers arrived in Ireland in 1856, and bought a three-storey farmhouse, called Mount Argus. Immediately, they added on a chapel, seen here on the right of this sketch. (Courtesy of the Passionists)

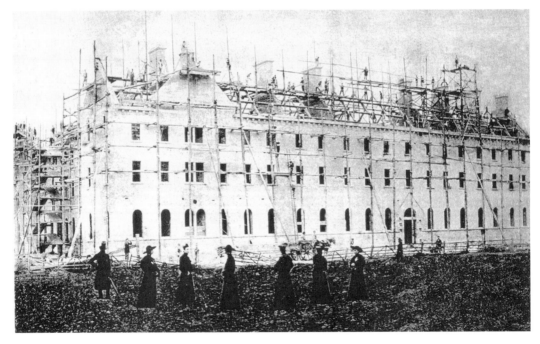

St Paul's Retreat was completed by the Passionists in 1863, using direct labour and sub-contractors, all managed by the priests. Note the timber scaffolding. The present church was built later, between 1873 and 1878. (Courtesy of the Passionists)

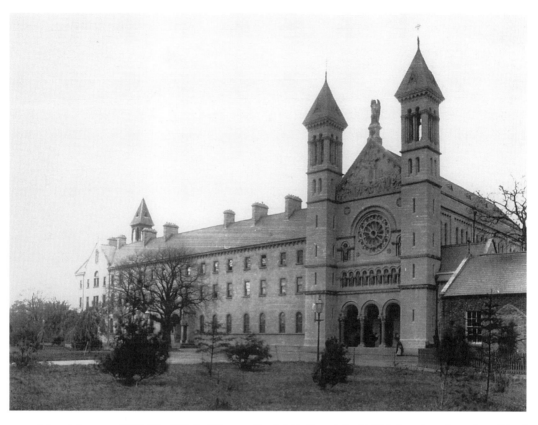

Mount Argus, *c.* 1890. The little building on the right is the original 1856 chapel, and was demolished in 1893. (Courtesy of the National Library)

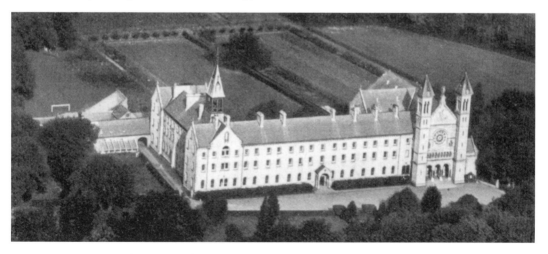

Mount Argus in the 1930s. The Retreat House (Novitiate) was L-shaped, and the church had no transepts or apse. Note the handball alley on left, and goalposts. (Courtesy of the National Library)

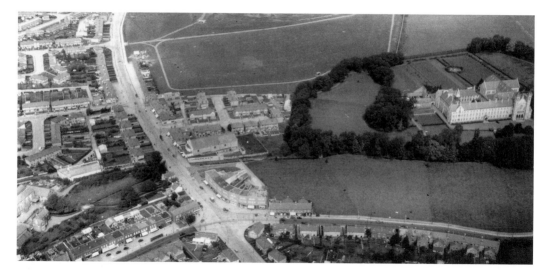

A 1950s photograph of Mount Argus, showing the rear two-storey extension to Retreat House, and transepts added to church. At the bottom left is the Larkfield Mills, where A-company, Fourth Battalion, Dublin Brigade of the Old IRA, was based for the 1916 Rising, including Joseph Mary Plunkett. It is now the site of Superquinn, Sundrive Road. (Courtesy of the National Library)

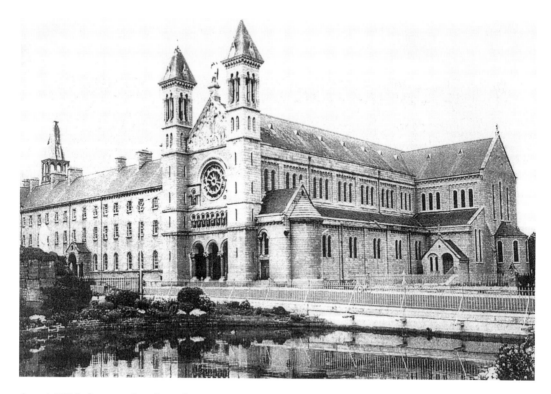

A post-1938 photograph, taken after transepts were added to the church. There was a large pond in front of the church, with statue of Our Lady, carved by Deghini, and this was originally a mill pond for Loader Park paper mill. (Courtesy of the Passionists)

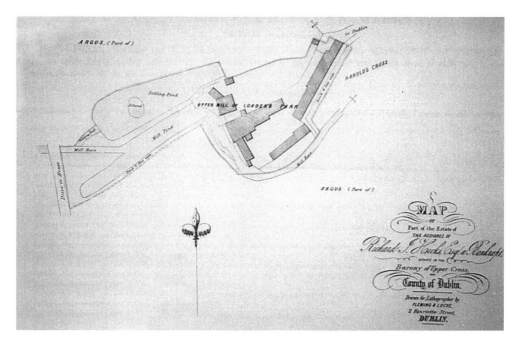

A 1857 map of Loader Park Paper mill (which dates from the early eighteenth century), showing the mill pond and settling pond, all fed from the River Poddle. Two long terraces of workers' cottages are visible to the right-hand side. Mount Argus monastery was at rear left. (Courtesy of the National Archives)

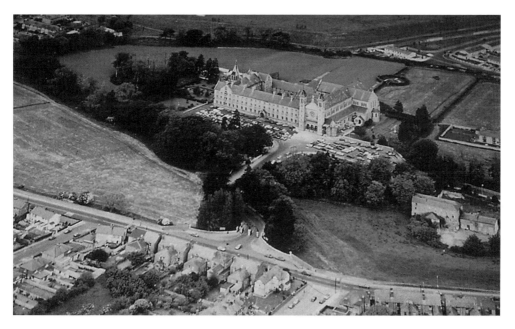

1983 photo of Mount Argus, before part of the farm was sold for private housing. Sundrive (Eamon Ceannt) Park is at the top of photo while Loader Park mill is bottom right and the Little Sisters of the Assumption is centre right. (Courtesy of the Passionists)

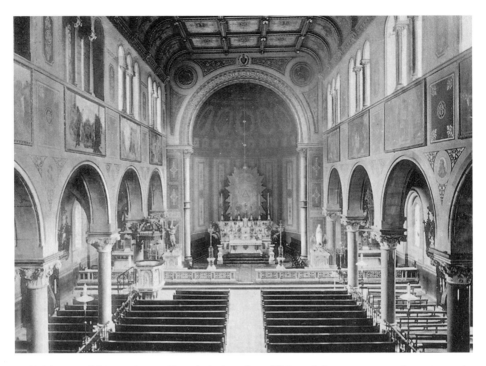

A 1924 view of Mount Argus Church, before the addition of the transepts and sanctuary in 1938. (Courtesy Mount Argus Archives)

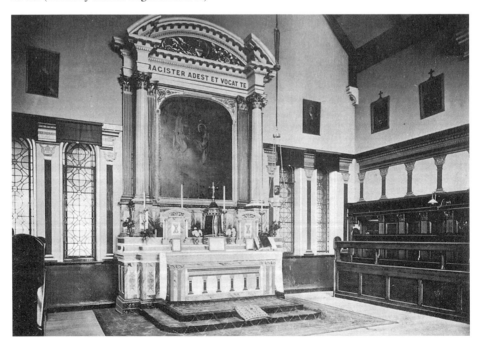

The Passionist's Choir (1884) was on the second floor of the monastery, with windows overlooking the public church. This image was taken in 1924. (Courtesy of Mount Argus Archives)

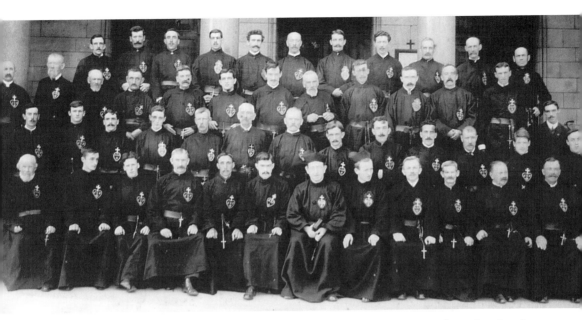

Men's Confraternity, 1911. These are all lay people, who served as stewards in the church on Sundays, and were very privileged to be allowed to wear the full Passionist habit up until the 1930s. Confraternities/sodalities met on a weekday evening once a month for Benediction and a sermon. (Courtesy Mount Argus Archives)

Workers on the new transepts and sanctuary of Mount Argus church in 1937. Note the timber scaffold poles. (Courtesy Mount Argus Archives)

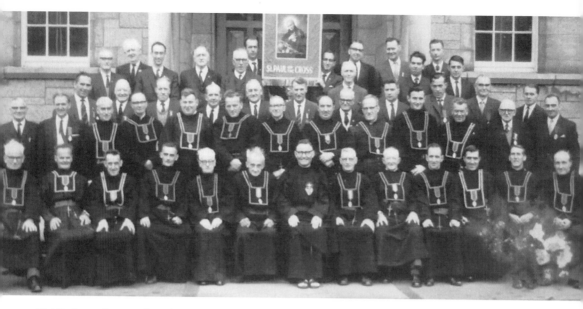

Habited members and prefects of the men's branch of the Archconfraternity of the Passion, in front of Mount Argus Retreat House, with Fr Columb in 1963. (Courtesy Mount Argus Archives)

Prefects of the women's branch of the Archconfraternity of the Passion, with Fr Evangelist in 1963. (Courtesy Mount Argus Archives)

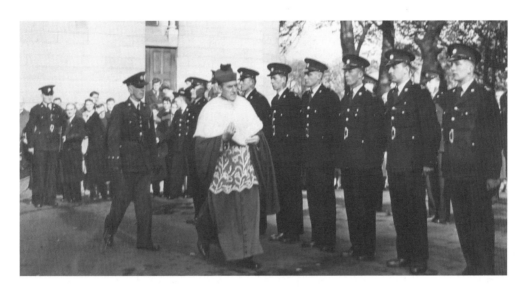

Archbishop McQuaid inspects his Guard of Honour in front of Mount Argus in 1963, during the blessing of the new gates from Kimmage Road, donated by the Garda Siochána. The Gardaí hold their annual Retreat in Mount Argus, and the Passionists act as Chaplin to the force. (Courtesy Mount Argus Archives)

President Mary McAleese, and husband Martin, attend the mass in Mount Argus on 3 September 2006, for the 150th anniversary of the founding of Mount Argus in 1856, watched by Father Martin Coffey, Provincial.

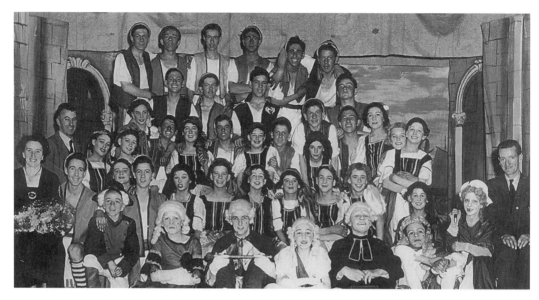

A 1954 performance of *The Gondoliers* in Mount Argus (former Loader Park mill). May Spinks and Michael O'Connor on left, with Andy O'Loughlin on right. This was the forerunner to the Harold's Cross Musical Society. (Courtesy of Mount Argus archives)

Loader Park mill was acquired by the Passionists, and used for St Gabriel's Youth Club, a boxing club, and amateur musicals. This photo shows a dance for St Gabriel's Club in 1954. (Courtesy Mount Argus Archives)

6

RIVERS, CEMETERIES, BARRACKS

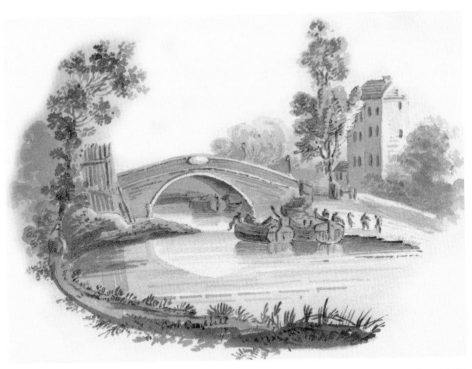

A watercolour of Clanbrassil Bridge (now called Emmet Bridge) looking east, painted in 1817, by Cecelia Margaret Campbell. The section of Grand Canal from Suir Road to Ringsend was built in the 1790s, with Clanbrassil Bridge opened in 1791. The bridge was rebuilt in reinforced concrete in 1936, and re-named Robert Emmet Bridge, because the patriot was captured in a nearby house in 1803, and publically hanged that same year in front of St Catherine's Church in Thomas Street (Robert was a Protestant, aged 25). (Courtesy of the National Library)

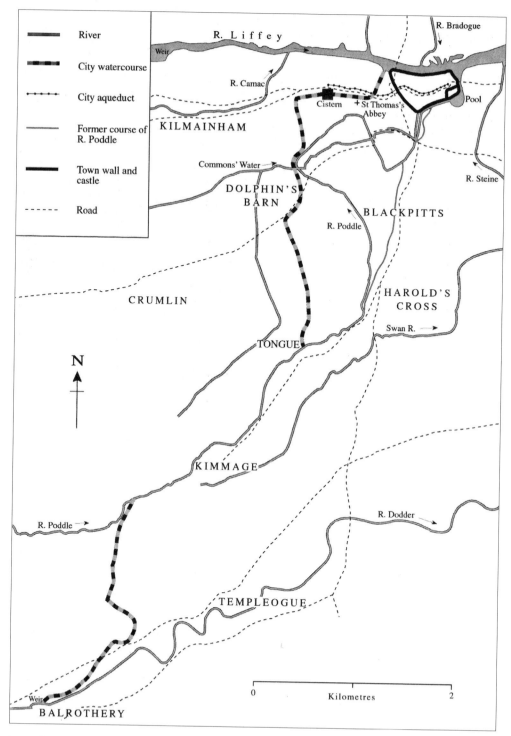

Map of River Poddle. Note the 'Tongue', where it splits in Mount Argus. The Swan River is also shown crossing Harold's Cross Road at the top of Leinster Road. (By permission of the Irish Historic Towns Atlas, Royal Irish Academy. © RIA)

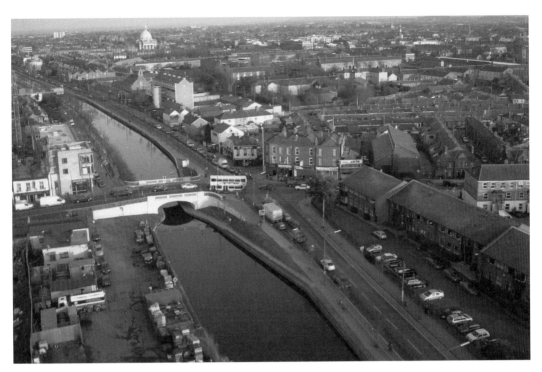

A recent photograph of Emmet Bridge. Gordon's Fuel Yard can be seen at the bottom left while the tower crane marks the site of an abattoir.

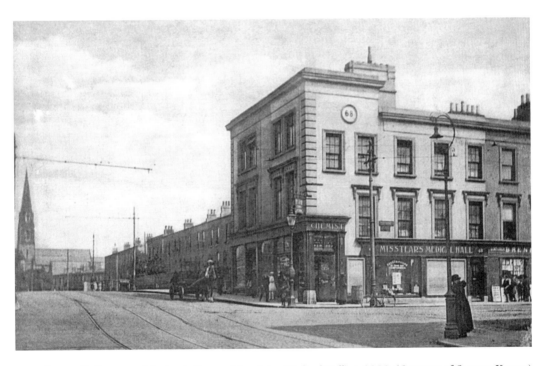

Leonard's Corner, or Misstear's Corner (chemist or Medical Hall), *c.* 1900. (Courtesy of Seamus Kearns)

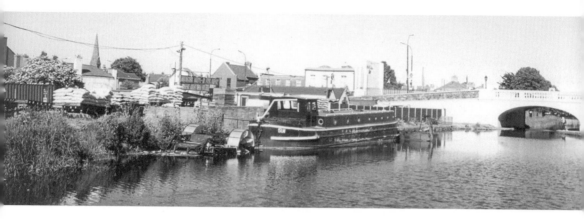

A modern photograph of Emmet Bridge, with Gordon's Fuel depot on the left. To the left of the barge is a special paddle boat for churning up the weeds.

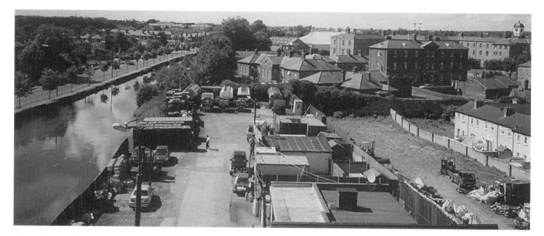

A modern photo of Gordon's fuel yard, with Griffith College in background (formerly Richmond Penitentiary, and then Griffith Barracks after 1922). Mullen's scrapyard on right.

Upper Clanbrassil Street. McKenna's pub is on the right, followed by Man of Achill pub, then Mullen's scrapyard, and lastly Gordon's fuel depot beside the Grand Canal. Harold House pub in centre left. The 'Man of Achill' was previously known as 'Ye Olde Grinding Young', dating from 1760.

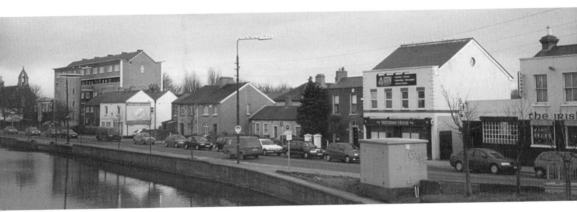

The Irish House pub on the right is now a block of apartments, and likewise the Grove Inn just past the block of Corporation flats. St Patrick's Garrison Church in Cathal Brugha Barracks is on left of this recent photo.

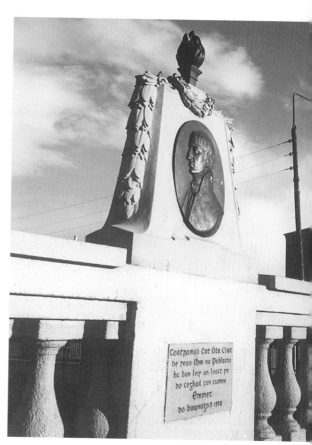

The 1938 Robert Emmet plaque, by artist Albert Power, on the bridge.

This was No. 5 Harold's Cross, *c.* 1917 (beside the present 23 Harold's Cross Road), where Robert Emmet was captured in 1803. A small limestone plaque marks the site. (Courtesy of Brendan Crowe)

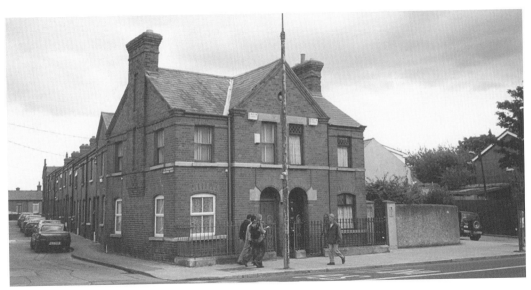

Armstrong Street, built by Dublin Artisan Dwellings in 1885. Emmet plaque is on the gate pillar to the right of the red-bricked house.

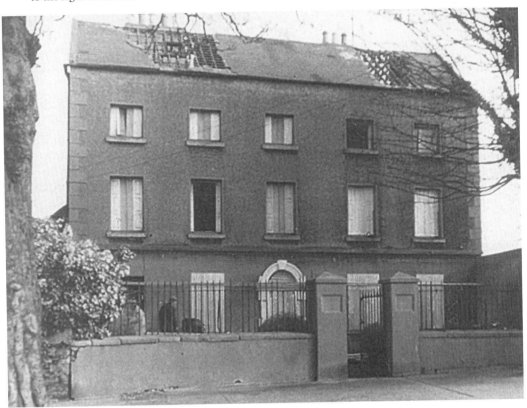

This was incorrectly known as Emmet House, at the bottom of Mount Drummond Avenue (formerly called 'Hen and Chicken Lane'). Emmet was captured in a smaller house on the main road, on the left-hand side of present Le Vere Terrace. (Courtesy of Brendan Crowe)

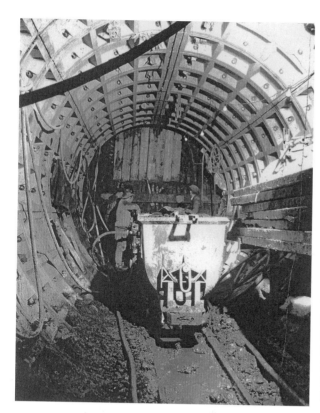

The Grand Canal Drainage Scheme in January 1973. It involved tunnelling for a sewer parallel with the canal, but below the canal. Buchan Ltd employed Donegal men to do the hard graft. (Courtesy of Dublin City Council)

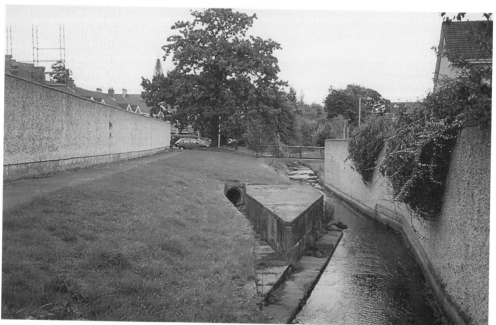

This 'tongue' or 'stone boat' was built in 1245 to split the River Poddle, with one branch supplying Dublin city, and the other branch supplying the local mills. It can still be seen at the south of Mount Argus, near Sundrive Road.

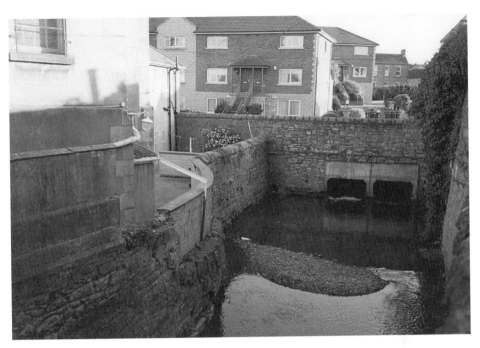

The River Poddle can still be seen on the south side of the Russian Orthodox church (formerly Anglican). Laurence Court townhouses in the rear are on the site of the Harold's Cross Laundry, formerly a flour mill.

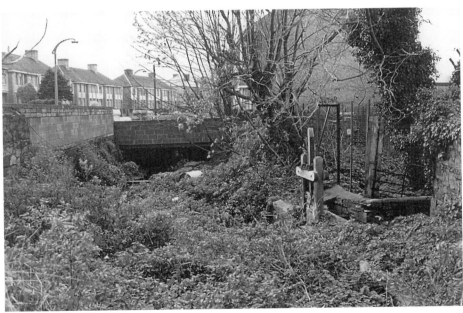

The River Poddle at the bottom of Kimmage Road, opposite the side of the Park Inn pub. The sluice gates on the right controlled the flow to the waterwheel on the outside of Harold's Cross Laundry. Now the site is occupied by Laurence Court townhouses. (Courtesy of Dublin City Council)

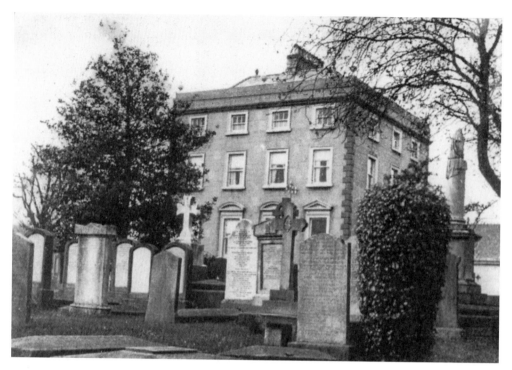

Mount Jerome House in the 1930s before the top two storeys were removed. This was the home of John Keogh, friend of Wolf Tone, and probably dates from the mid-eighteenth century. The cemetery was founded in 1836. (Courtesy of the National Library)

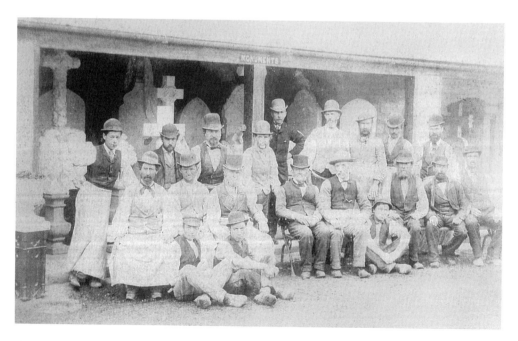

A group of stone carvers in Mount Jerome in 1874. (Courtesy of Brendan Crowe)

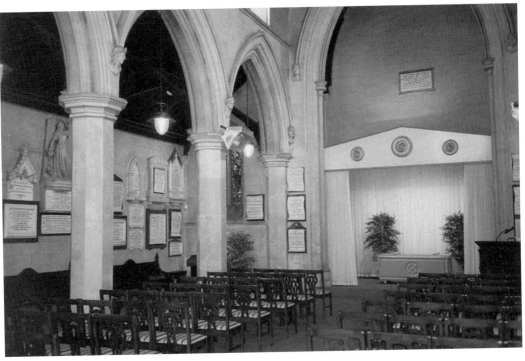

Inside the 1847 mortuary in Mount Jerome, which was modernised in recent years.

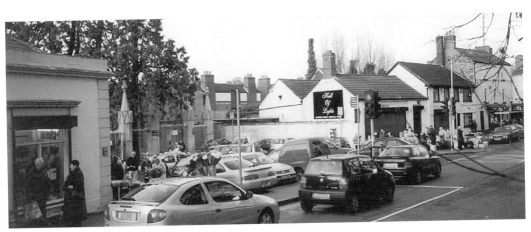

A modern photo of Mount Jerome entrance, with Flynn's Flowers on left, and street flower vendors on right. The original Harold's Cross National School is in the centre (now Hall of Lights).

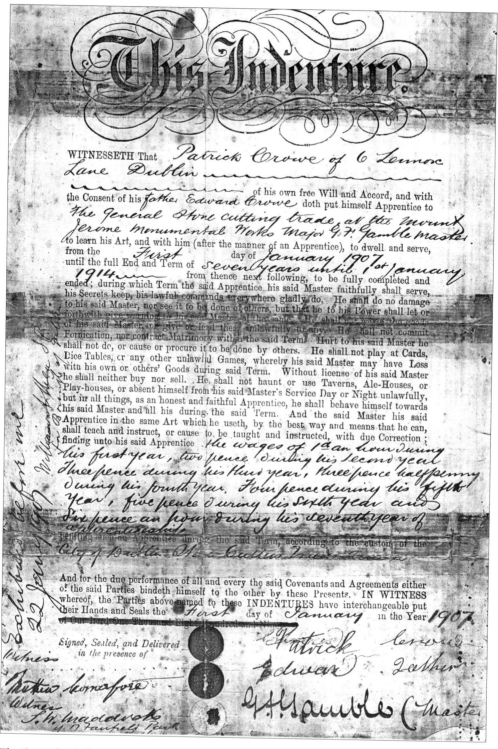

This Indenture

WITNESSETH That *Patrick Crowe of 6 Lennox Lane Dublin* _____ of his own free Will and Accord, and with the Consent of his *father Edward Crowe* doth put himself Apprentice to *The general Stone cutting trade, at the Mount Jerome Monumental Works Major G.F. Gamble master* to learn his Art, and with him (after the manner of an Apprentice), to dwell and serve, from the *First* day of *January 1907* until the full End and Term of *Seven years until 1st January 1914* from thence next following, to be fully completed and ended; during which Term the said Apprentice his said Master faithfully shall serve, his Secrets keep, his lawful commands everywhere gladly do. He shall do no damage to his said Master, nor see it to be done of others, but that he to his Power shall let or forthwith give warning to his said Master of the same. He shall not waste the goods of his said Master, nor give or lend them unlawfully to any. He shall not commit Fornication, nor contract Matrimony within the said Term. Hurt to his said Master he shall not do, or cause or procure it to be done by others. He shall not play at Cards, Dice Tables, or any other unlawful Games, whereby his said Master may have Loss with his own or others' Goods during said Term. Without license of his said Master he shall neither buy nor sell. He shall not haunt or use Taverns, Ale-Houses, or Play-houses, or absent himself from his said Master's Service Day or Night unlawfully, but in all things, as an honest and faithful Apprentice, he shall behave himself towards his said Master and all his during the said Term. And the said Master his said Apprentice in the same Art which he useth, by the best way and means that he can, shall teach and instruct, or cause to be taught and instructed, with due Correction; finding unto his said Apprentice *the wages of 1d an hour during his first year, two pence during his second year three pence during his third year, three pence halfpenny during his fourth year. Four pence during his fifth year, five pence during his sixth year and Six pence an hour during his seventh year of apprenticeship* Finding such an Apprentice during the said Term, according to the custom of the *City of Dublin Stone Cutters Trade Union*

And for the due performance of all and every the said Covenants and Agreements either of the said Parties bindeth himself to the other by these Presents. IN WITNESS whereof, the Parties above-named to these INDENTURES have interchangeably put their Hands and Seals the *First* day of *January* in the Year *1907* of Our Lord One Thousand Eight Hundred and Nine

Signed, Sealed, and Delivered in the presence of

Witness Patrick Coroners
Witness F.W. Maddocks of 17 Fairfield Park

Patrick Crowe
Edward Crowe father
G.H. Gamble (Master)

Signatures before me William Maja ? 22 Jany 1907

The Crowe family have been stone carvers for generations. This deed of apprenticeship, dated 1907, was for seven years, under Master Gamble. (Courtesy of Brendan Crowe)

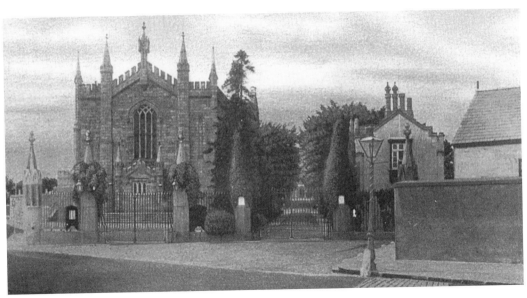

Pre-1907 postcard of the entrance to Mount Jerome. Note the Harold's Cross National School on right, before the front yard was built over. (Courtesy of Seamus Kearns)

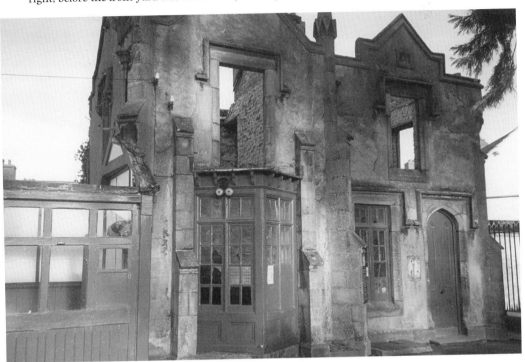

The 1860 Mount Jerome Lodge was a little gem, and was modernised recently for re-use as a family home. The basement is only visible from the rear. The public Waiting Room was on the left.

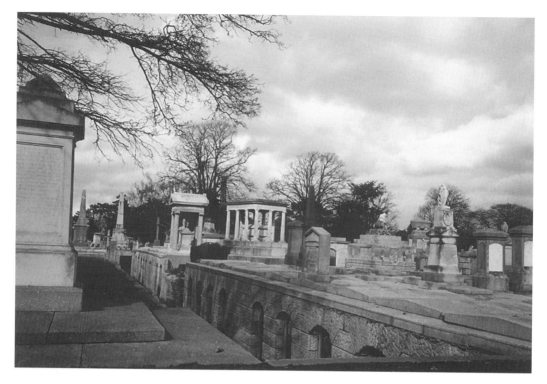

The old part of Mount Jerome Cemetery is full of beautiful monuments, carved by the best craftsmen. Note the burial vaults owned by important families.

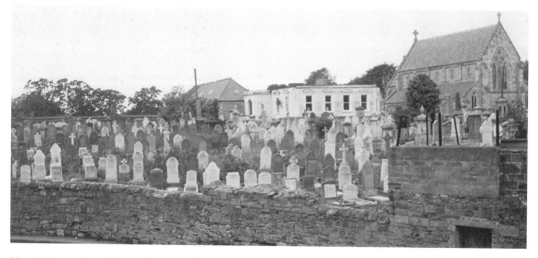

Mount Jerome from Mount Argus Road. The old house is reduced in height and used as offices, cafe, toilets. The 1847 mortuary is now used for various religious farewells, including cremations. The walled garden is now full of graves, and the wall is gone. The old stable building to the left of the house is now another mortuary.

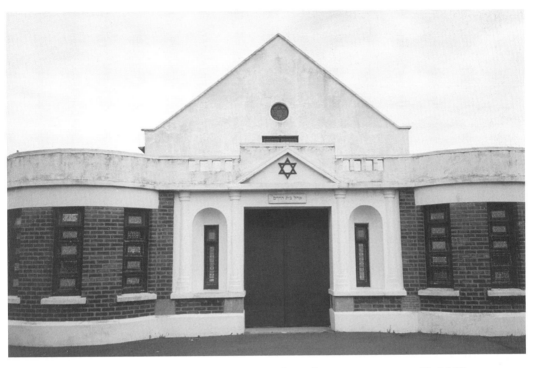

The Jewish cemetery on Aughavanagh Road, beside Scoil Iosagain, was opened in 1898.

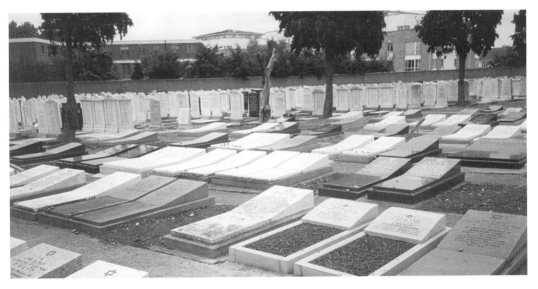

The Jewish cemetery. In background, on the left, is the Christian Brothers house.

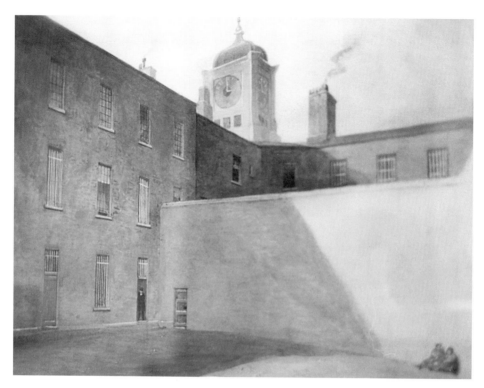

1844 painting of Richmond Penitentiary, by Henry O'Neill, RHA, during the time of Daniel O'Connell's imprisonment for three months. The penitentiary was built in 1813. It was converted from prison to army barracks in 1890s, and renamed Griffith Barracks in 1922. It is now used by Griffith College (third level). (Courtesy of the National Museum)

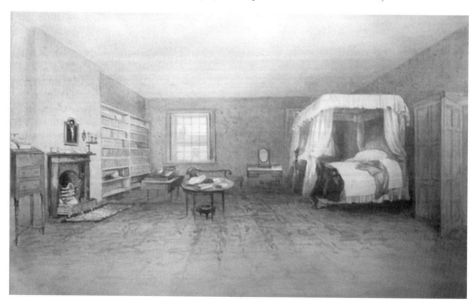

1844 painting of O'Connell's bedroom in Richmond Penitentiary, during his imprisonment. (Courtesy of the National Museum)

Portobello Barracks was built in 1810-15, and was actively involved in quelling the 1916 Easter Rising. It was re-named Cathal Brugha Barracks in 1952, thirty years after Independence, despite the fact that it was the Army HQ of the Irish Free State, and Michael Collins, as Commander-in-Chief, lived in Red House, from May to August 1922. The barracks is now active in UN peacekeeping missions, and is the home of the Army School of Music and the Army No. 1 Band, who practise in the hall behind Grosvenor Square.

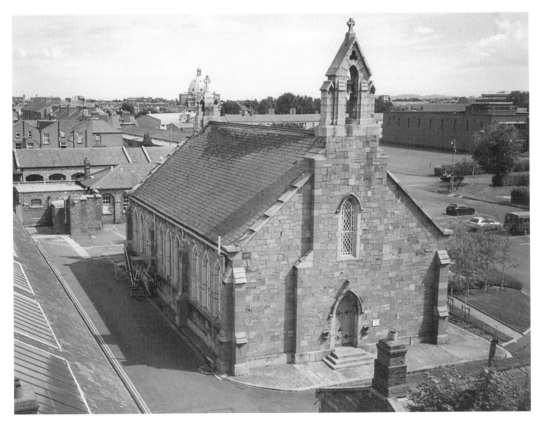

St Patrick's Garrison Church (1842) in Cathal Brugha Barracks – was originally Protestant. There are lovely stained-glass windows by Evie Hone behind the altar. Rathmines church dome can be seen in the background, and Grove Road along left side.